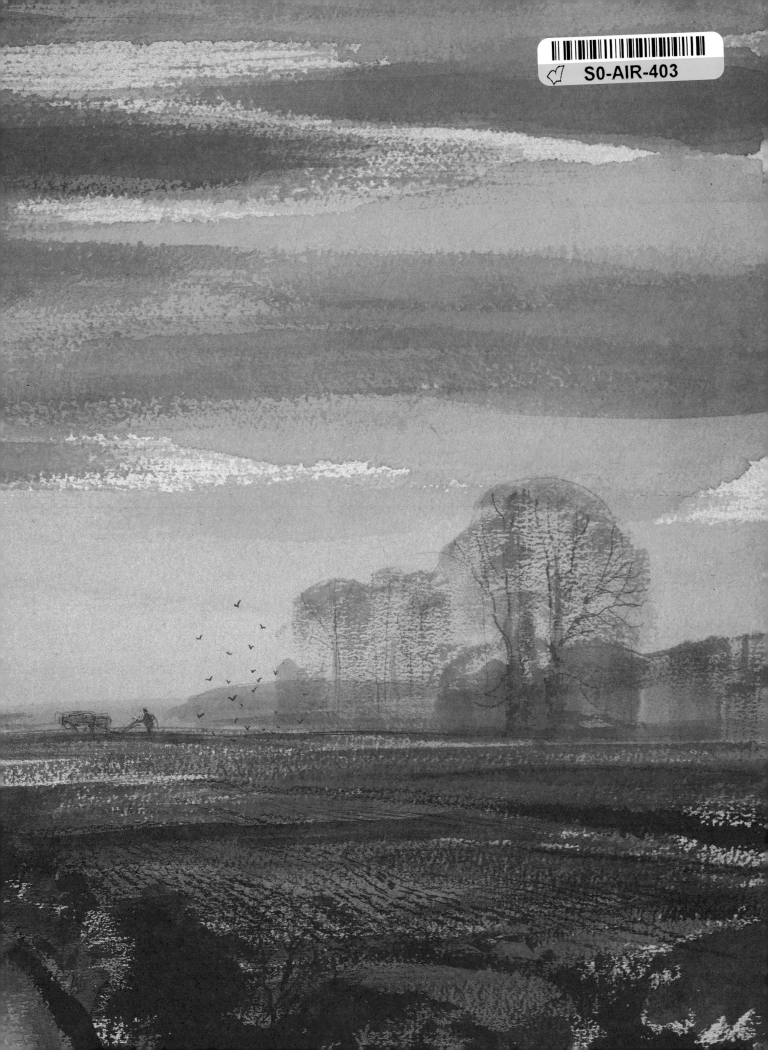

Starting with
Watercolour

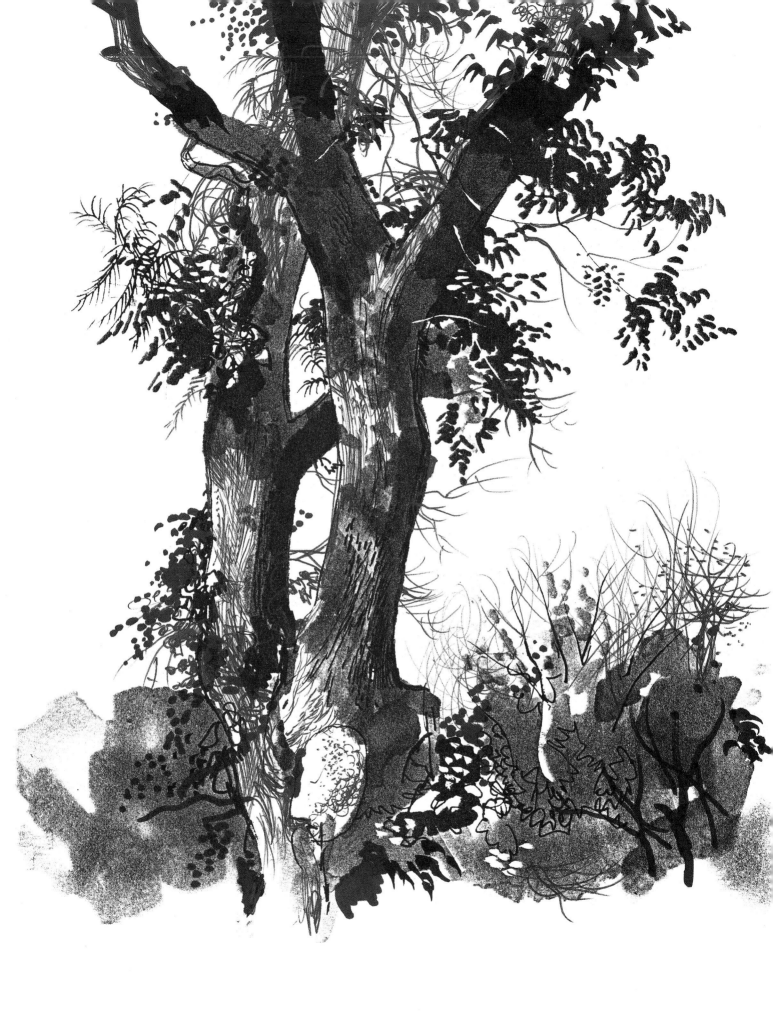

Starting with
Watercolour

Rowland Hilder

The Herbert Press

Copyright © Rowland Hilder 1966, 1988
Copyright under the Berne Convention

First published 1966
This revised and enlarged edition published 1988 by
The Herbert Press Ltd, 46 Northchurch Road, London N1 4EJ

Reprinted 1988

Typeset by BAS Printers Limited, Over Wallop, Hampshire
Printed and bound in Hong Kong by South China Printing Co.

British Library Cataloguing in Publication Data:
Hilder, Rowland, 1905–
 Starting with watercolour—Rev. and enlarged ed.
 1. Watercolour paintings—Manuals
 I. Title
 751.42′2

ISBN 0-906969-85-9

Contents

Foreword

Starting with Watercolour first appeared in 1966 as a volume in a pocket-size series of instructional works. It was very successful, reprinted several times and translated into six languages.

The early editions are now out of print, and my publisher, David Herbert, suggested re-issuing the book in a larger format more suitable to the needs of today's readership. This has made it possible to include a substantial number of full-colour illustrations, more step-by-step treatments and some examples of my recent watercolour work. The text has been revised to take into account a number of developments in painting materials and techniques. I hope it will prove to be as useful as the previous edition.

ROWLAND HILDER

Introduction

Watercolour painting is to oil painting what the string quartet is to the full orchestra. Each is a great art form in its own right. Watercolour is a responsive, sensitive medium; it excels as a means of capturing and conveying the inspiration of the moment. By its nature it is ideally suited to combine the techniques of both drawing and painting in tone and colour. If style can be defined as economy of means, then watercolour is better suited than any other medium to be a vehicle for rapid direct expression. It is particularly suited to convey the feelings evoked by the moods of nature, responding in capable hands to the changing seasons and the fleeting beauties of the weather.

While watercolour painting has been accepted as an outstandingly beautiful and responsive art form, it has also earned the reputation of being the most difficult to master. A wealth of dogma and ritual has grown up as a by-product of the teaching of watercolour painting, which has been formulated into sets of rigid rules which inhibit rather than facilitate the mastery of the medium. It has been said that the best medium is the one which works well at the time and which best serves the purpose of expressing feelings and ideas in the simplest and most economical way. What one seeks in painting is a medium that exactly matches one's purpose. If traditional rules help us to this end, then it is clearly to our advantage to accept them as far as they work – but to disregard them the moment they do not.

I can remember dogmatic instructors who laid down the law and paid lip service to the rules. 'You must not use opaque colour!' 'You must confine yourself to what are called the gentlemen-colours – yellow ochre, burnt sienna, ultramarine, cobalt blue and aureolin yellow.' 'You must not use pen or carbon pencil.' In fact you must not indulge in any procedure that departs from the strict definition of pure watercolour. To do so would be to indulge in 'trickery', which implies a sin akin to cheating.

I found that these ideas hampered and frustrated me. Attempting work within the limitations imposed by these rules seemed to place a restriction on the kind of subject that could be tackled. The visual experiences which really excited me seemed to call for a more flexible means of expression. When I tried to paint the moving white sails at Cowes regatta, I found it impossible to capture the scene by following advice which involved painting a transparent watercolour sky and leaving the sails as the natural white of the paper. The yachts had moved away before the first wash was dry! By experiment I found that I got very much what I needed by painting the sails in opaque white body-colour on a tinted paper.

Later, when I visited the Tate Gallery in London and saw the wonderful Turner sketches, I was delighted to find that he had used body-colour, chalk, pencil, pen and watercolour where and when it suited him. In short, Turner had simply made the medium his servant, while my instructors were the servants of their own sterile dogma.

Today we live in an atmosphere of experiment. The pendulum has swung so far in the other direction that perhaps now new dogmas are being created to hamper us: 'You must not be guilty of illustration', and so on. Yet with all this, there is a feeling of abandon in the field of painting today. Painters throw and dribble paint, slash their canvas, build impasto with cement, attach mirrors and electric lights, drive in rusty nails and incorporate old bedsprings. At last I feel free to use masking medium! I hope that in turn the student will not consider the rules I make here binding. What I have written is intended as a guide and as a stimulant. It is my aim to open the doors and to initiate the student into the practice of the most wonderful medium of expression yet devised – that of watercolour painting in its fullest and widest sense.

Line drawing

Man has drawn in line since the beginning of recorded time. To do so seems as much a part of his nature as to communicate by speech. Most children will attempt line drawing at a very early age, and cave men, the Indians, the Persians, the Egyptians, the Greeks, the Japanese and western man drew fascinating and moving pictures in line. It was only during the Renaissance that chiaroscuro (the art of conveying the impression of relief by the use of light and shade) was discovered. Development of this discovery led eventually to the exclusion of the use of line and to the degeneration of painting, taking it in the direction of being a medium used to create representational pictures with a photographic quality.

Today the reaction against this attitude has been so violent that many contemporary painters rebel against the conception that art should in any way seek to simulate visual appearances. Yet calligraphic line work has been the basic ingredient of all the great art

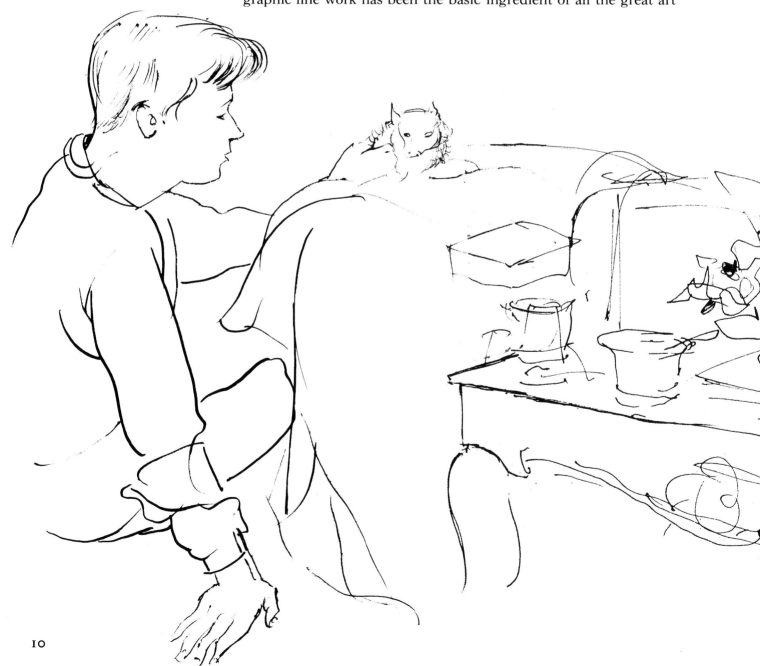

10

styles. In view of this I feel confident in beginning this book by advocating the practice and development of the art of line drawing as a prelude to its becoming an integral part of the watercolour technique.

Subsequent sections will deal with painting in tone and colour, and will aim at guiding the student to use line not as an aid to producing guide lines 'to be coloured in', but to promote an easy marriage between line and colour as a prelude to the development of a responsive personal style of painting.

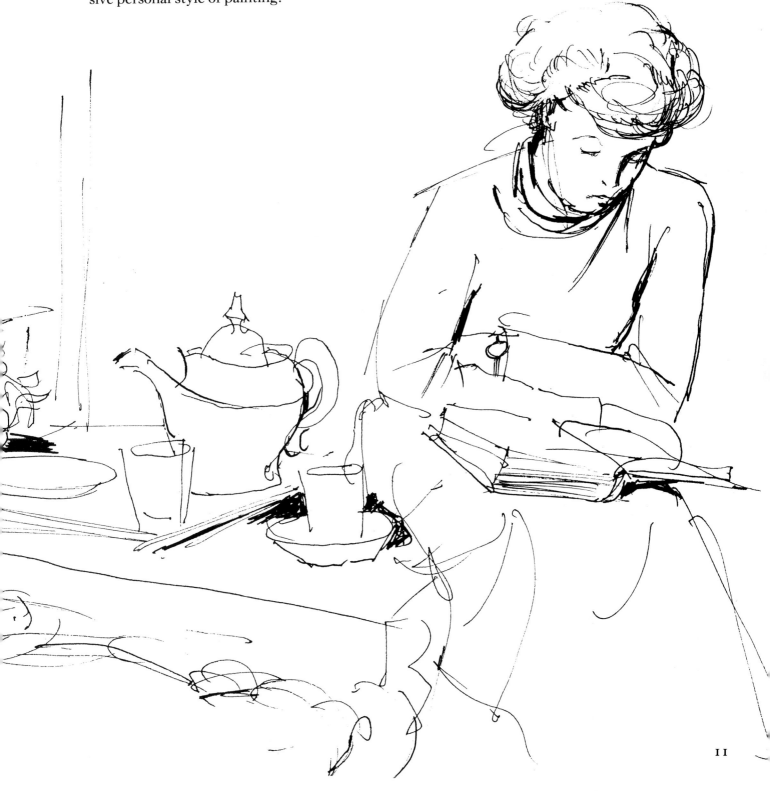

Exercises in drawing

You learn to draw simply by continuing to draw. While engaged in drawing practice, you need to be free from worry and anxiety about the process and free from worry about the cost of materials, the possible waste of time, whether or not you are making progress, what people will think of your work or whether what you are doing is good or bad and so on.

The cost of materials need not be great. All you need is plenty of paper and something to draw with. Try a ream or two of cheap typing paper and an ordinary ballpoint pen. Begin to draw fearlessly with something that will make a clear black line. Draw the things around you: the room, the table laid for a meal, the view from the window. Just start drawing and keep on drawing. Draw rapidly and in the first instance do not be unduly worried about accuracy. If you draw a line in the wrong place make a correction on the same

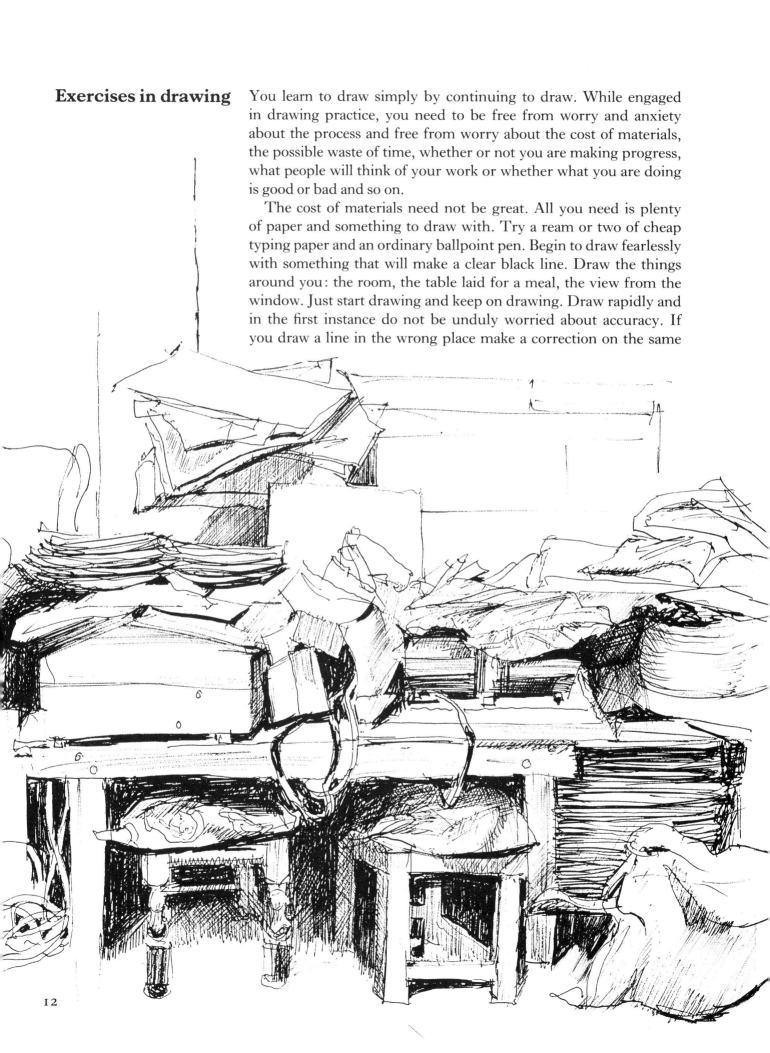

drawing with a bolder, firm line. Aim at making the subject and the line come alive. At all costs keep going, even if the efforts do not seem impressive. When you are puzzled as to how to proceed, or when your interest flags, look at reproductions of the drawings of the masters.

Make quick free-hand copies of their works. Find out and understand how they put a drawing together, and above all what they leave out. Aim at expressing yourself in line with confidence and assurance. You must believe in what you are doing. The whole business is largely a confidence trick. Half the battle in learning to draw is believing and knowing that you can do it. It's like learning to ride a bicycle – if you lose confidence, you fall. You have to learn to guide the bicycle along a certain path. So with learning to draw, you have to learn to put the line where you want it to go. To do this you have to develop the channels of communication between mind and hand, so that the hand will automatically be able to put on paper what is in the mind's eye.

Drawing instruction can be useful, but no amount of instruction can replace actual practice. The drawing instructor's chief function is to engender and maintain enthusiasm and to stimulate the growth of confidence.

Are there any helpful rules? There are a few, but again none that will replace practice. Remember also that rigid rules can hamper as well as help. The rules of drawing and painting are there to be broken, if they do not serve your purpose in developing a technique that will eventually express your own personality.

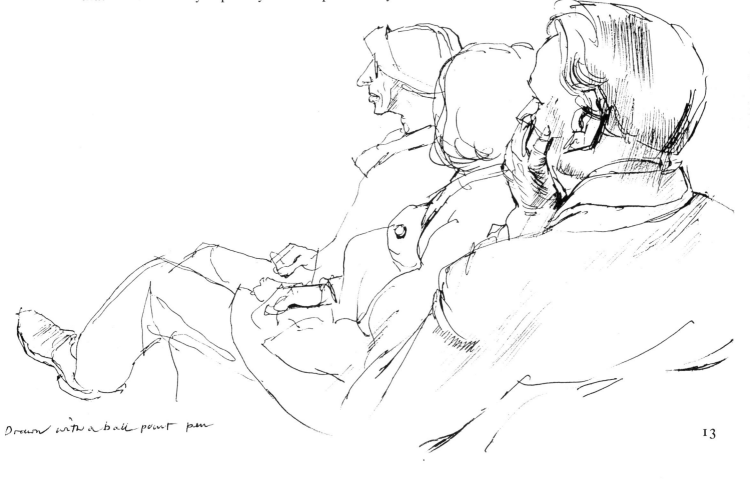

Drawn with a ball-point pen

13

Thick and thin lines

The rule is that thick lines appear to come forward and thin lines, by comparison, to recede. This formula will not automatically create a masterpiece, but the principle can be used to very good effect. Using this simple rule you will find that you can create a line drawing on one, two or three planes.

Study the style of artists who excel in line drawing. Imitate their work if you like it. Don't be afraid of not being original to begin with. Let your style develop in its own way; it will evolve from practice and from your personal interests and preferences.

Soon you will wish to branch out and experiment with various kinds of drawing materials. To draw both thick and thin lines you require something that will draw these lines readily. A black ballpoint pen will serve very well for the thin lines. It is easy to carry and use, and you don't risk upsetting bottles of ink when walking about the house. Felt pencils are ideal for thicker line work. Several kinds are now available, giving a choice of width and thickness.

Pen pencils are often a delight to use. The black pens and markers are particularly useful; in most cases the ink flows easily, giving a clean black line which is an almost ideal drawing medium when used in conjunction with watercolour. However a word of warning: great

care must be taken when purchasing markers to be used for watercolour work, to be quite certain that each marker is in fact waterproof. This can be done simply by drawing on some scrap paper and by applying a little moisture. It is a great pity that some of the most responsive markers and pens are not actually waterproof. I personally have ruined line drawings by adding watercolour washes to water soluble line work. Though I find it useful to carry a responsive non waterproof marker for making notes where additional tones and colours can be added in pencil. Also when sketching on a toned paper, one can make use of some really excellent white pencils now offered, and which can be sharpened enough to sketch such detail as light twigs as seen against a dark background.

There is today, however, a wonderful selection of really waterproof ballpoint and marker pens available in a variety of sizes and colours. They vary from fine pointed to the wide felt pens that can be used to block in extensive areas.

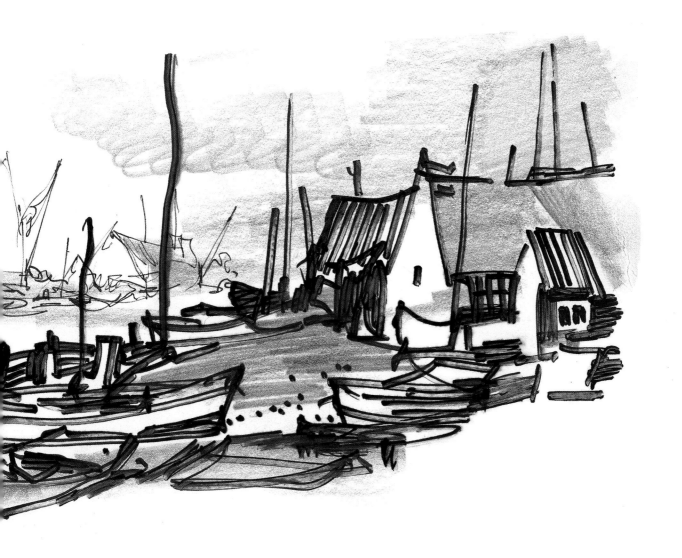

A large number of coloured markers are now offered, giving an extensive range of tones and colours. However, on hearing it said that these were not permanent I decided to run a test. I did this simply by drawing coloured lines on paper and by masking one half while exposing the other to direct sunlight. Alas nearly all the colours faded in little over six weeks, which is a great pity as the coloured markers promised to be a most useful medium used in conjunction with watercolours. Let us hope that a way will be found to make them permanent! I, however, continue to use some of the lovely basic greys and browns for making rapid notes on location. This idea works reasonably well provided the sketches are not exposed to continuous daylight. They seem to keep moderately fast when kept in the dark.

Rembrandt made his drawings with a quill pen, achieving a rugged dynamic line that would almost certainly be unattainable with the modern steel nib. It is interesting to note that he diluted his ink to create a fainter line which he used most effectively to simulate the effect of atmosphere and distance. I personally favour drawing with a piece of sharpened stick dipped in Indian ink. The wood absorbs a certain amount of ink and acts as a natural reservoir. The

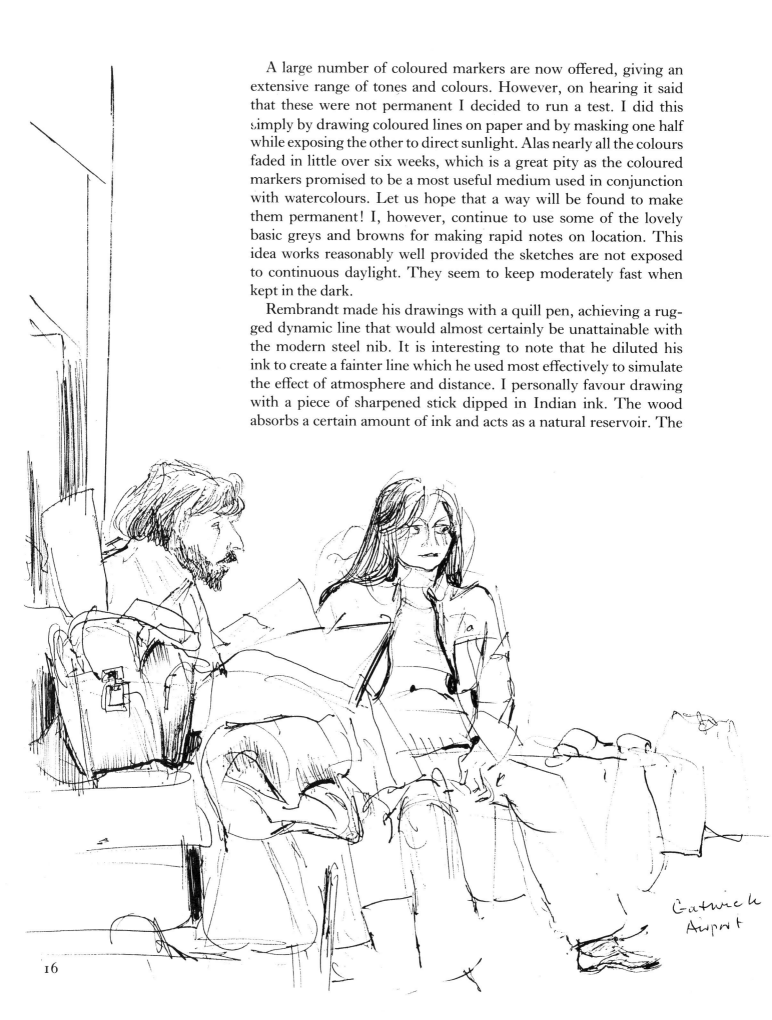

Gatwick
Airport

inked stick will make a brisk, rough, granulated line when used on rough paper. It can be used very effectively in conjunction with a steel pen, which in contrast produces a hard fine line.

Having grappled with the initial stages of line drawing and gained experience, you will be ready to begin to develop a sense of relationship between objects. In forcing yourself to draw in line, you are at the same time developing the technique of making a selection. You are learning to leave out those things which slow down and detract from the exciting briskness of a drawing. The essence of style is the art of selection. The good draughtsman keeps the drawing alive. He doesn't overload the work, making it static and tedious. He keeps to essentials, making a crisp direct statement.

Having begun to link objects in your line drawings, you can now consider giving emphasis to significant parts of the composition by the addition of areas of black. It could, for example, be a black coat or hat on a foreground figure, or it could be a cat or even a black shadow well placed in a sketch or an interior scene.

With experience, you become increasingly aware that the lines in a drawing can be made to create a sense of movement. You will begin to sense the rhythmic effect of certain kinds of line arrangements, and soon appreciate that a complicated piece of line work will be seen better when it is placed against a simple background. You will learn to avoid the temptation to overload certain areas, and how to direct attention to the parts of the drawing that you wish to stress.

Pencil

Up until now I have avoided mentioning the use of lead or carbon pencil. The object of the drawing exercises already outlined is to get you to embark on the road to making direct, bold, black line drawings. Having done this, you can now add pencils to your list of essential materials. These will have a special use in the production of the line and tone studies and sketches you will want to make as an aid to your watercolour work. Having developed the technique of making direct line drawings reinforced with areas of solid black, it is now a good time to try adding half-tones with lead and carbon pencil. You will find that the pencil, even when used moderately heavily, creates a grey tone relative to the blackness of the line work. Experiment by laying varying degrees of tone and observe the effect. Use lead pencil for the lighter tones and a 2B carbon pencil for the

deep tones. You are now working towards a combination of line and tone, and developing a line and tone shorthand technique of making a statement that will become the basis of a good watercolour style. Many of the sketches shown here were made on a cheap linen-grained writing paper, using ink for the line and a carbon pencil for the additional areas of tone.

When making these line and tone drawings, it is absolutely essential to keep the patterns of tone as flat as possible, and to avoid at all costs the temptation to niggle and to add realistic or photographic detail. The art of drawing and painting is the art of selection and simplification. First the selective treatment of form and movement in terms of pure line and then the addition of selective tones in terms of pattern.

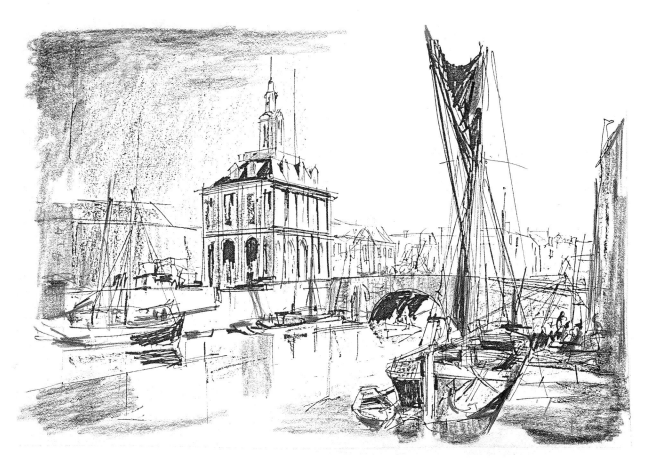

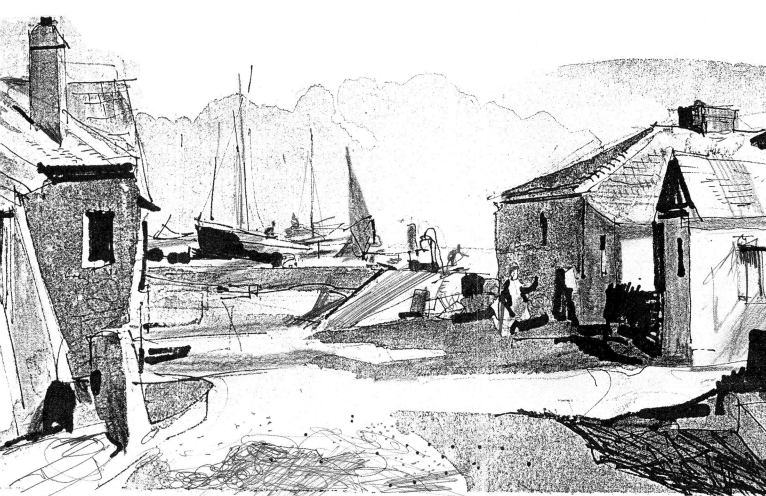

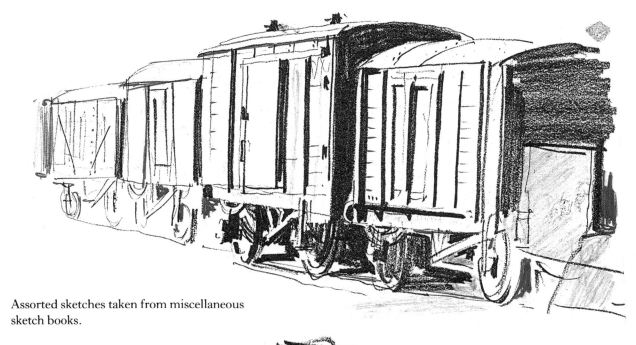

Assorted sketches taken from miscellaneous
sketch books.

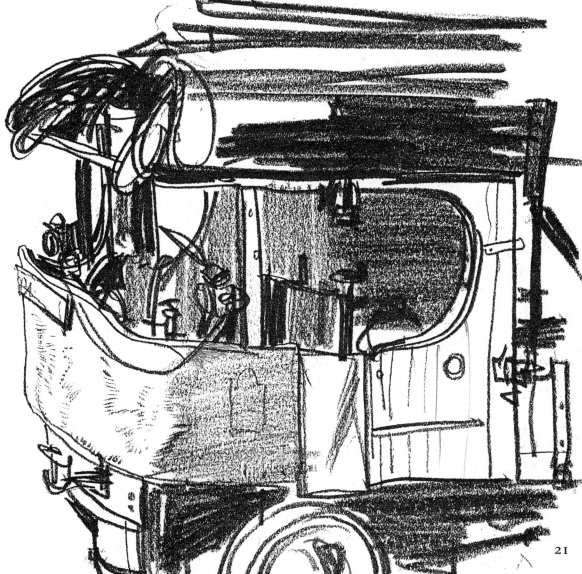

21

Drawing with a brush

It is essential to use good brushes for watercolour work. These are expensive, but with careful handling they should last a long time. Remember that Indian ink should not be allowed to dry on a brush. When using a brush for ink work, keep a small jar of water handy, and immerse the brush the moment it is not in use. When you have finished work, wash the brushes gently in warm soapy water, easing away all traces of ink with the fingers.

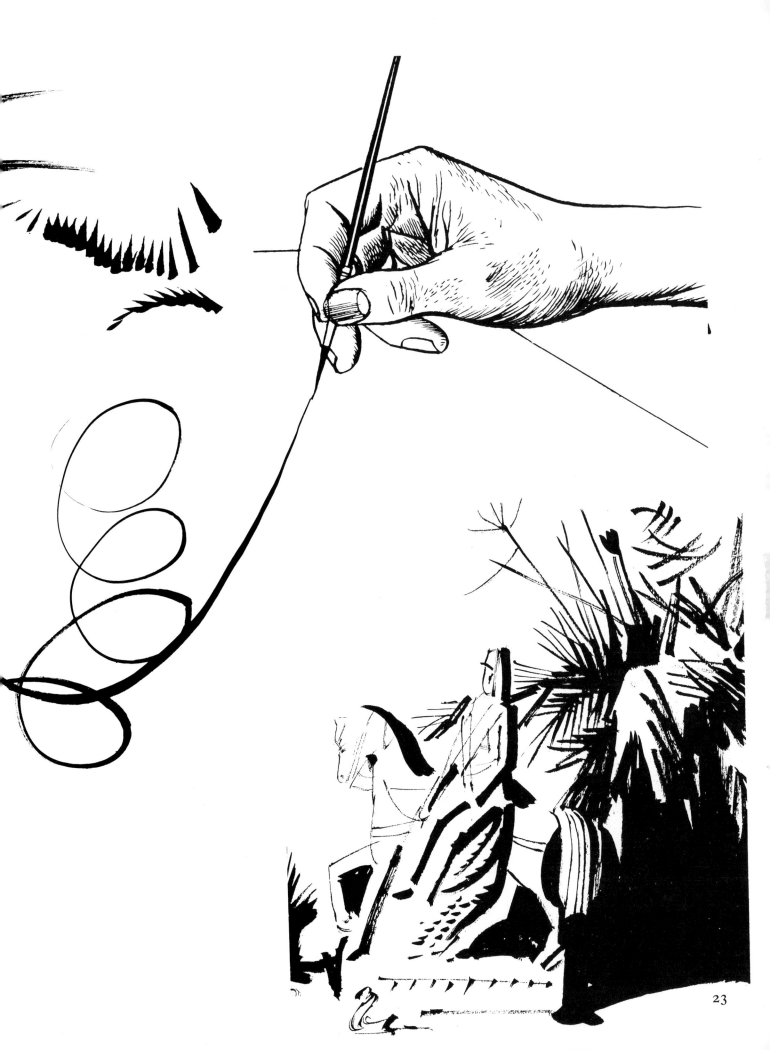

A no. 3 brush was used for the illustrations opposite and on this page. When buying a new brush, it is advisable to test it to ensure that the hairs come to a perfect point. To do this dip the brush in water and shake it out. The hairs in a good brush will then come naturally to a sharp point. To make fine, clean, even lines, the brush should be supported on the second finger. Allow the finger nail to glide freely over the surface of the paper, making free bold strokes from the elbow. Gradually lower the brush down the supporting finger until the tip just touches the paper. Now practice making free, fine lines. Practice making circles and long looped lines.

The thickness of the line is increased by lowering the brush slightly down the supporting finger. Practice making graduated strokes. Place the tip of the brush on the paper. Lower the brush down the finger, increasing the thickness of the line as the stroke is made. Constant practice and experiment will enable you to develop many different qualities of line. If the ink does not flow easily, dilute it with a little distilled water.

Before attempting to draw a fine, even, brush line, it is advisable to try the point on a piece of scrap paper to ensure that the brush is charged with the correct amount of ink. You will find that a brush rather sparsely charged with ink will produce a broken or granulated line which can be used to good effect in some kinds of work. Practice making long, thin, wavy lines by drawing the brush down the paper towards you in one free, direct movement.

The ability to draw directly with a brush is absolutely essential to the art of good watercolour painting. It is obvious that an enormous amount of practice will be necessary before you can draw directly and cleanly with a brush. The Chinese are trained to use a brush at a very early age, and are given exercises in the various strokes used in both their writing and painting. The Japanese flower painters carry a variety of brushes with a variety of length and thickness of hair. The long bamboo leaf seen so often in oriental paintings is painted in one stroke, using a special brush for the purpose. To draw a short stubby leaf, the point of the brush is placed on the paper and the body of the hair is made to touch under pressure, making a pointed, thickening line simulating the shape of a leaf.

Having got your brushes, you must draw at every opportunity. Draw while you talk to people, draw while you listen to music. Try to draw the faces you see on television, the cat in front of the fire, people as they sit reading or knitting. Draw a hand, a sleeve, a foot – anything, just keep drawing. Seek to convey the impression of the object in the simplest possible way. Do not get side-tracked into feeling that you are obliged to copy everything before you. Make a selection of those things that most interest you, and set out to make a simple statement in line.

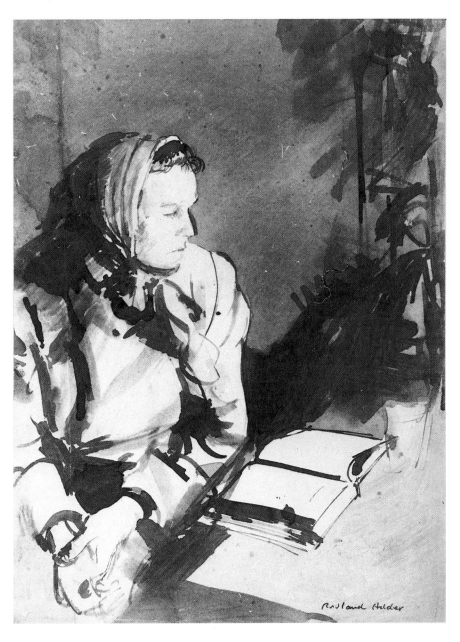

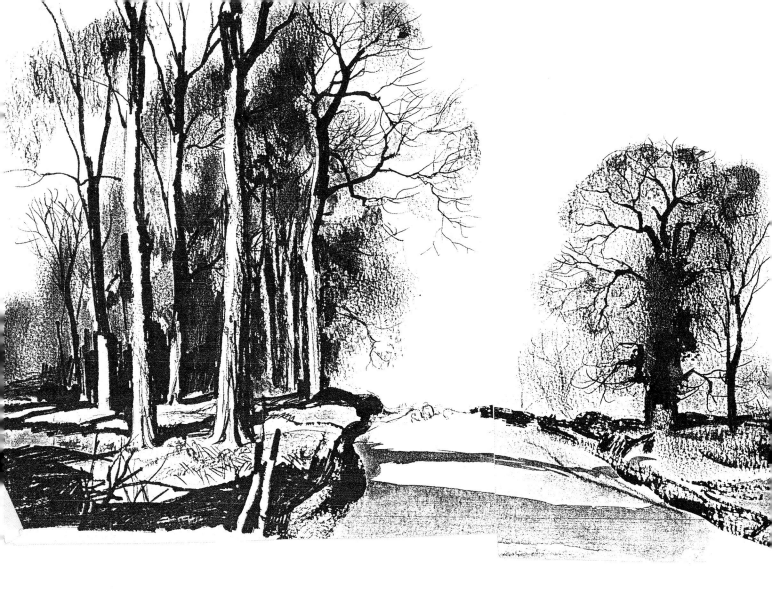

Charcoal

You will now be ready to develop towards the art of composition, and at this stage you will find the use of charcoal most helpful. You need some sticks of vine charcoal and a soft clean rag for dusting. The first experiments can be made on ordinary typing or cartridge (drawing) paper.

View your subject through half-closed eyes. Try to ignore detail and to become aware of the main shapes and contrasts of tone, that is, to see the subject in terms of mass. Block in the main areas and shapes boldly with charcoal, then dust the surface with the cloth, removing most of the charcoal. This will leave a faint image which will serve as a basis for correction and further development. If you already find difficulty in getting the correct proportions, you will soon discover that the use of charcoal to establish the main shapes and areas will be of great assistance. You can either leave the drawing as it is, as a charcoal sketch (in which case you must fix it at once), or you can use the faint charcoal image as a basis for a line and tone drawing. For example, having blocked in your main shapes, use a black felt pen or 2B carbon pencil to strengthen and consolidate the

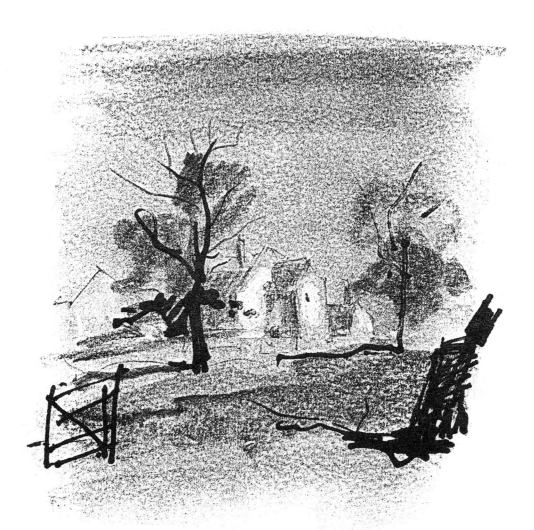

blacks. A grade B carbon pencil will be most useful for additional half-tone work.

You will almost certainly find that having dusted the work several times in the charcoal stage, you are left with a tone of charcoal over the surface of the paper. You can now create white areas by removing the charcoal where required with a plastic rubber, which can be moulded to a point in the hand. Avoid the temptation to niggle and to become involved in too much realistic modelling. Keep the work crisp and clear, with the emphasis on shape and pattern. If the finished work is to be preserved, it must be fixed. This can be done by spraying it with fixative, which can be blown on through a glass tube. Better still, you can use one of the pressurised aerosol sprays. If you have a heavy deposit of loose charcoal, the work should be given a very light spray first, taking care not to disturb or blow away any of the charcoal. This initial film of spray should be allowed to dry for half a minute before a second application. It may be necessary to spray the work a third time to ensure that the charcoal is completely fixed.

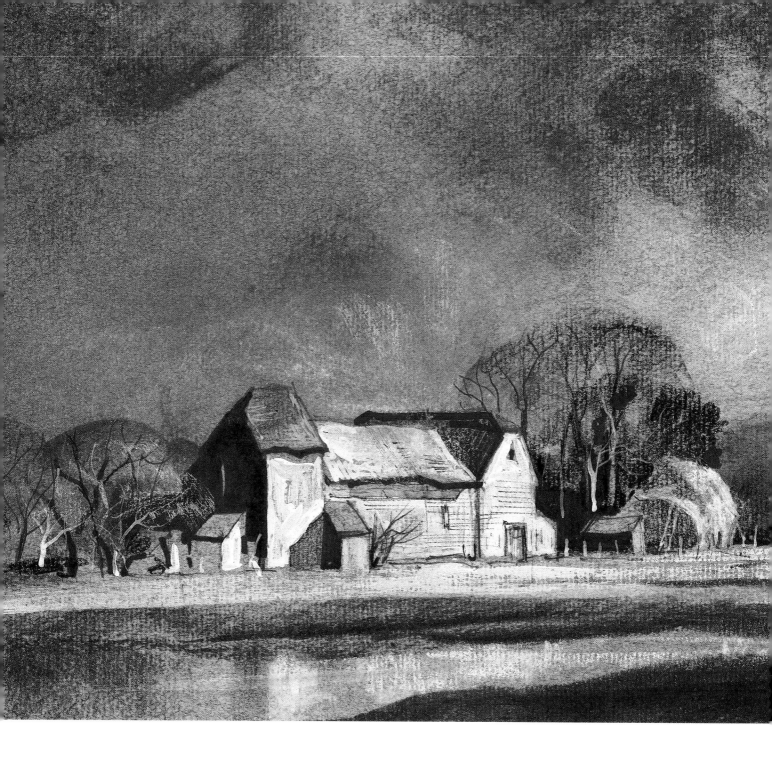

Drawing on toned paper

Now that you are developing your line drawing towards a fuller tone conception, this is a good time to try using toned paper. Buy a selection of tinted grey papers and a piece of fairly hard white chalk, pastel or crayon. Work on the grey paper as you would on white, beginning your drawing in bold outline with the addition of black accents where required. Now add your deep areas of tone with a B or 2B carbon pencil, and your lighter tones with a B lead pencil. Finally pick out your whites and light areas in white chalk. As you

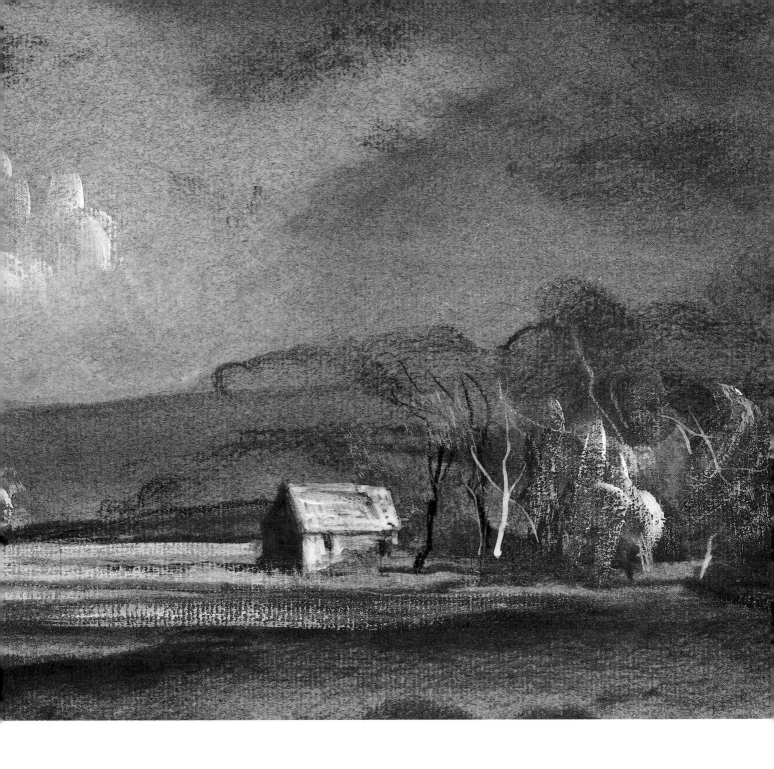

proceed with this technique, you will begin to notice the importance of significant whites in your picture. You will see that a sketch should not have more than one area of pure white, and that this should occupy a central and important position. Before trying this technique on an outdoor subject, it might be a good idea to try copying one of the tone and chalk illustrations in this book, just to make sure that you can control the various degrees of tone. This will also help you to gain confidence.

Tone exercises

What is tone? To the layman the word conveys very little, but to the painter it has a very special meaning. It means the co-ordination and control of tone values, the art of making a clear statement using simple flat areas of tone, the ability to see nature in terms of tone – and much more.

Understanding the technique of painting by tone values is by far and away the most important key to an understanding of painting. To help the student of watercolour painting to understand the basic principles of tone painting, I have devised some tone exercises. To carry them out you need Indian ink, brushes and paper, and lamp black watercolour. Stout or moderately heavy cartridge paper would serve for the first experiments. The scale need not be large – a sheet 10″ × 6″ would suffice.

Before attempting a picture, it is necessary to make a tone test, rather as one would tune a musical instrument before use.

First brush some Indian ink on to the paper, making a moderate sized rectangle. (The brush should then be washed clean in water – Indian ink should not be allowed to dry on a good watercolour brush.) The patch of black ink will now represent the darkest possible tone. The blank paper will remain the lightest tone. All other tones in the painting must now fall between these two extremes.

Next paint a watercolour wash that is just a degree lighter than the black. You will notice that the black wash will lighten in tone as it dries, and I would be very surprised indeed if you succeeded in making the wash dark enough at the first attempt. One has in

fact to mix what appears to be a jet black wash before anything like the required depth of tone is achieved. Having established a tone a degree lighter than the ink black, paint another tone a degree lighter still. You should aim at producing at least four distinct tones of grey, ranging between the black and the white of the paper. Also have four mixed tone washes in four separate dishes ready for the painting of the first experimental tone picture.

Before starting, it is essential to choose a subject that can be simply rendered in areas of flat tones. As a beginning it might be a good idea to try copying the arrangement in the illustration below.

First outline the shapes of the tones lightly in pencil. Then paint in the black areas with Indian ink. Next note the position of the clear white areas. Then apply a flat wash of the lightest tone for the sky. Take this wash right over the whole picture, except of course for the white areas. When it is absolutely dry, you can then apply the next tone down the scale. Keep each wash absolutely flat and even. One of the basic qualities of watercolour painting is directness of statement. To achieve this, you must aim at establishing the correct depth of wash the first time. Avoid having to go over washes to increase depth, as this gives the painting a tired, dead appearance. Also avoid the temptation to touch up or niggle in order to achieve a sense of high finish. Let the simple flat areas of tone, by their correct intensity, convey the sense of ordered reality. For example, you will see that the trees in the illustration below are indicated as flat areas of tone.

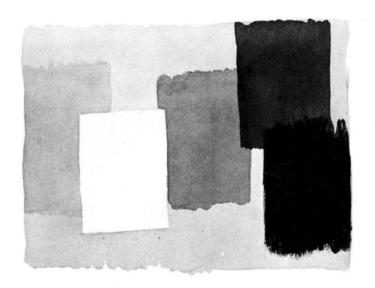

First exercises in controlled colour

Now let us proceed to the first exercises in the use of colour. These aim at developing the concept of tone painting in monochrome to embrace the concept of a colour key and the use of 'functional' colour.

To begin we must return to the four basic mid-tones of grey wash made from lamp black. To each tone wash now add a touch of burnt sienna, thus increasing the warmth of the tones and giving a near sepia colour. Make experimental brushings of the four tones, then add more burnt sienna to each and note the increased richness and warmth of colour.

Now paint a small simple tone sketch using the four tones of warm black brown and if possible introduce into the picture a small area of grey made from lamp black. You will notice that by comparison the grey will take on a bluish or 'cool' tone.

As with the monochrome washes, the colour washes will dry lighter. One must learn to anticipate the exact degree of change in order to strike the correct colour and tone at the first painting. Like the concert pianist, the student must practise scales to gain knowledge, skill and confidence.

Having obtained experience with lamp black and burnt sienna, you can now extend your palette to include a cold scheme simply by adding a little indigo to the original four tones of lamp black. A considerable number of brushings and painting must be done before one can hope to acquire anything like an intimate knowledge of the full range of colours and tones that this simple palette will yield. Having explored the range of tones and colours that can be made with lamp black and indigo, you are now ready to try painting in a combined warm and cool colour and tone scheme. At this point I would suggest making a number of simple sketches from nature. To begin with, keep the sketches small – say 6″ × 4″. You can now begin to co-ordinate direct observation of nature with the technical experience already gained indoors. It will become increasingly clear that there are fundamental rules relating to colour as well as to tone. Broadly speaking, cool colours (as with lighter tones) tend to recede into the distance, while warm colours appear to come forward.

This follows a fundamental principle in nature. The distant hills appear blue, while the earth in the near foreground is clearly a warm brown. Armed with this very simple rule, you can create the impression of vast depth and distance by the use of a few washes of the correct tone and colour.

Functional colour

You can use warm and cool colours to great effect in yet another way. Study the landscape on a fine sunny day and you will see that the lighter areas of sunlight appear warm, while the shadows are relatively cool – or of a bluish hue. The reds and yellows are the warm colours, and the blue the cold. If we now add yellow ochre to the palette, we will have the three primary colours in a muted form. As the sunlit areas are generally lighter, it would be a good idea to begin by painting a light wash of raw sienna over the whole surface before proceeding with the sketch. A little indigo can then be added to the shadow tones as well as to those tones which represent the distance. Note that both shadow and sunlit passages will appear to be warmer in the foreground areas.

It is most important to master the basic principles involved in painting by tone values, together with the principle of the warm and cold colour scheme, before proceeding to the next exercises, which involve the use of a fuller and more complicated palette.

When making the first experiments in colour, you should be very careful not to lose the threads of the earlier exercises in tone. Do not be tempted in the face of nature to niggle and to depart from the basic principle of creating a picture in terms of simple patterns of flat tone. When one adds the problems of colour to the problems of drawing and of tone, then one is beginning to have a lot to remember. For this reason, the first experiments on location should be based on the simplest possible subject matter. Choose subjects which can be clearly and easily seen and executed in tone, and which consequently lend themselves to the direct treatment of the watercolour medium.

Some may consider it a merit to be over-ambitious, but surely there is no virtue in being depressed and discouraged because one has failed to reach an impossibly high target.

It is well to remember that some of the greatest watercolour paintings were based on the simplest of subjects and often rendered in a few simple direct washes.

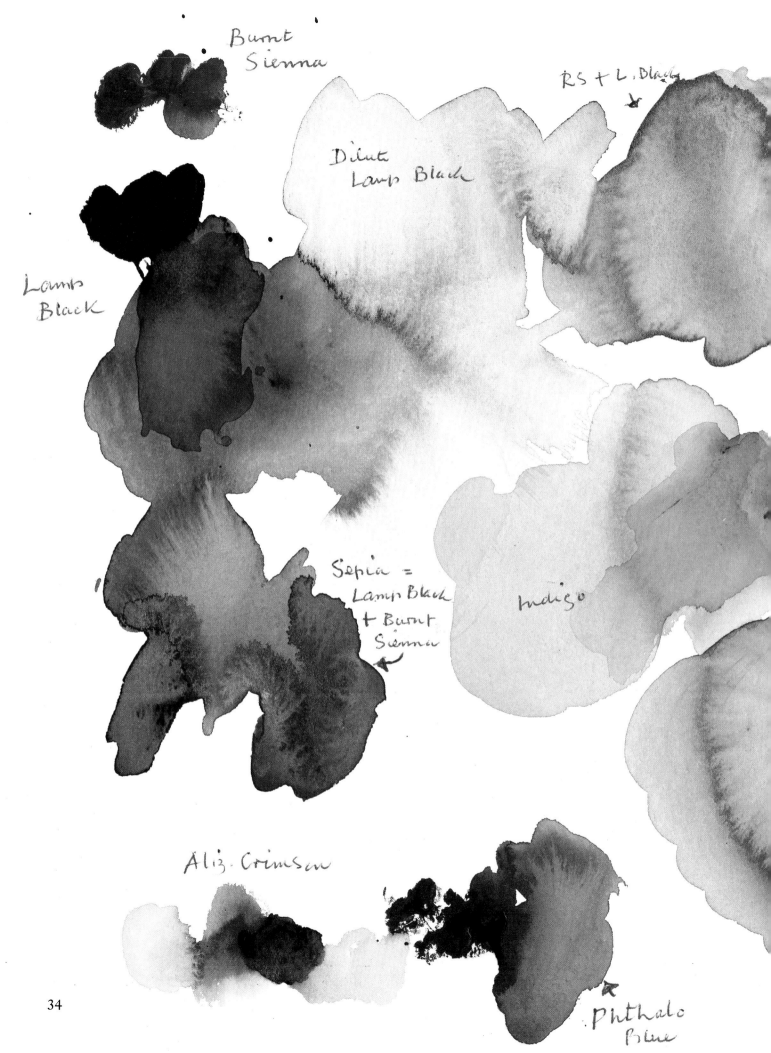

Burnt
Sienna

Dilute
Lamp Black

RS + L. Black

Lamp
Black

Sepia =
Lamp Black
+ Burnt
Sienna

Indigo

Aliz. Crimson

Phthalo
Blue

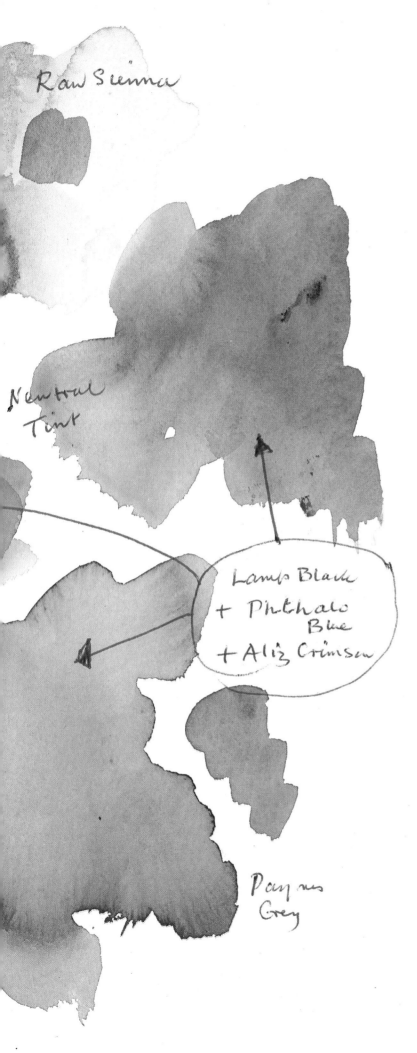

Raw Sienna

Neutral Tint

Lamp Black
+ Phthalo Blue
+ Aliz Crimson

Paynes Grey

Colour mixing Teaching based on the art of impressionism forbade the use of black but lamp black has traditionally been a basic pigment which can be made to produce numerous shades and hues of clear transparent light-fast watercolours. Today sepia is made by mixing lamp black and burnt sienna, while many famous colourmen make neutral tint, Paynes Grey and indigo from a varying mixture of lamp black and phthalo blue and alizarin crimson.

Paper

I have suggested that the first experiments should be made on small sheets of cartridge (drawing) paper because an enormous number of experimental brushings and trial washes will have to be made in order to gain experience. While cartridge paper will serve well enough for these preliminary exercises, it is unsuitable for more ambitious work. The full quality of watercolour can only be revealed when the painting is made on a good quality watercolour paper or board.

Watercolour paper is made with a variety of surfaces, ranging from smooth to very rough. The choice of surface is largely a question of personal taste, but I will outline some of the guiding principles involved in making a choice.

First, the larger the work, the rougher the paper. A fine texture is more suitable for detailed work, while a rough surface favours a broad treatment. As a general rule, heavy paper is better for larger work. It is usually easier to obtain an even flat wash on a rough surface, and the full beauty and transparent quality of watercolour is best displayed on a rough or moderately rough surface.

The palette

The best watercolour paintings are often subtle and subdued in colour. In selecting a palette we must remember that the objective of the watercolour painter is not to make a photographic copy of nature, but rather to achieve a synthesis that will convey beauty of feeling. In attempting this we must always bear in mind that many subjects are not best suited to watercolour, and that it is essentially a medium that lends itself to rapid, sensitive and responsive expression. To be successful we should seek to avoid complications. The palette must be selected to give a wide potential range of colours, in case of need, while at the same time it must be as simple as possible to operate. Pigments must be chosen that have those qualities specially suited to watercolour. They must above all be transparent and responsive to application in wash form – also they must be free from dirty and muddy qualities, particularly in the lower tone ranges.

Let us consider further colours in some detail. We have already considered the basic colours: lamp black, burnt sienna, indigo and raw sienna. To extend the range we must add brighter colours. For example *cadmium red* appears to have many advantages over the old

vermilion. It is more transparent, easier to apply in large washes, it does not turn brown when exposed to direct sunlight – and it is cheaper.

Phthalo blue simplifies the palette by replacing a number of blues previously carried, such as prussian blue, cobalt blue and cyanide blue.

Phthalo green deep has certain advantages over viridian, though the latter is still in many ways an excellent colour. The danger with the intense new phthalo green is that, being so powerful, it can dominate the palette, and in the hands of the careless or heavy handed the result can be devasting!

Cadmium lemon (not to be confused with cadmium yellow) is a powerful, permanent, cold, acid yellow, suggestive of a fresh spring day. Mixed with lamp black, it produces a beautiful olive green that is the colour of midsummer trees in leaf.

To this range one must add a pigment that will make the purple hues. However, alizarin crimson can serve a double purpose: when mixed with phthalo blue it produces a useful purple, and at the same time it is in itself an intense purplish red.

Burnt sienna plus phthalo green will give a deep, rich green the colour of summer foliage.

If you want to carry a light and limited range for sketching, the following will produce an almost unlimited number of colours:

Cadmium lemon, raw sienna, alizarin crimson, phthalo blue, lamp black and burnt sienna.

The above colours can be mixed to produce almost all the colours found in a landscape.

There are of course many other pigments offered; some have special qualities. For example, French ultramarine blue, particlarly when mixed with light red, will precipitate as it dries, producing a granulated texture which is often effective when used by good watercolour painters. For the beginner, however, I would strongly advise prudence. The best watercolour painters carry surprisingly few colours. Painting directly from nature is difficult enough, without having to ponder on how to mix the required colour.

As each new colour is added to the palette, the student should explore the fresh possibilities offered by making numerous experiments in mixing colours. This way he will be able to create any colour and tone when required.

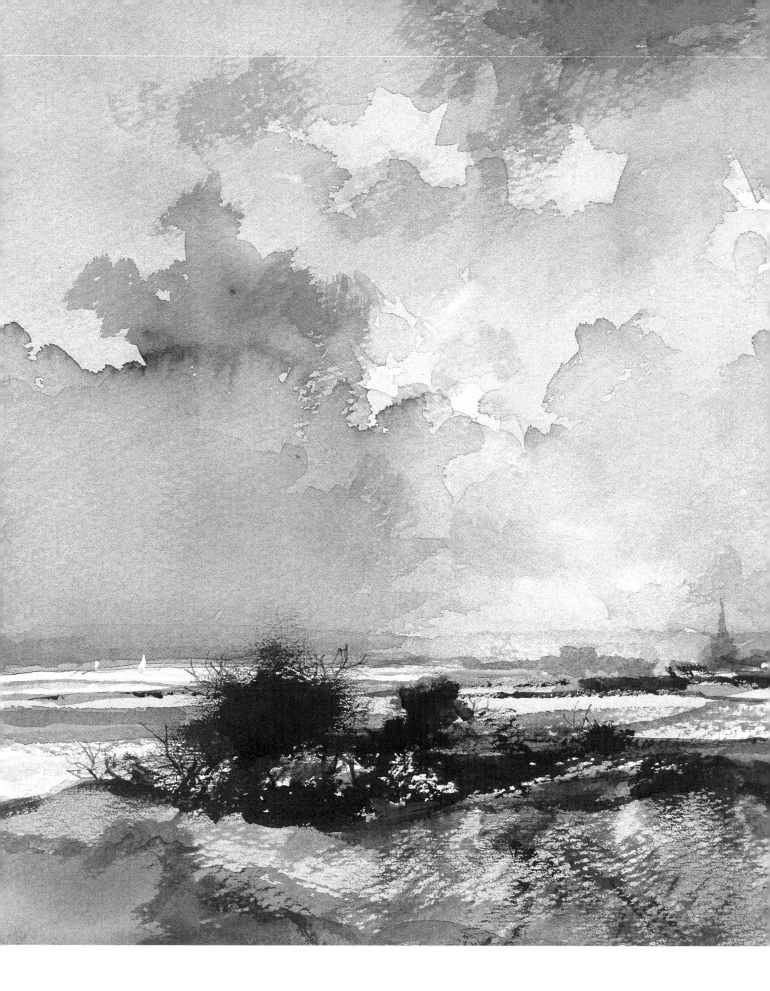

38

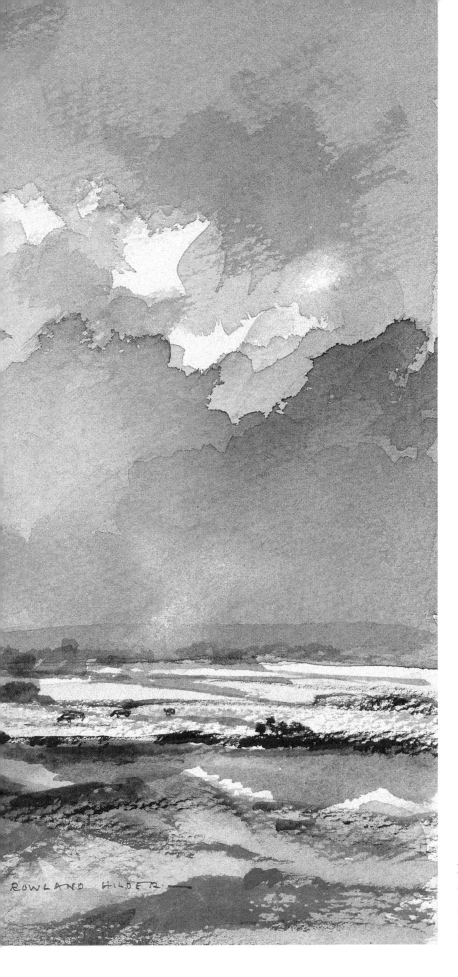

A landscape making use of a simple basic palette of lamp black, raw sienna, burnt sienna and indigo with the additional use of a black marker pen to indicate the twigs in the foreground bush.

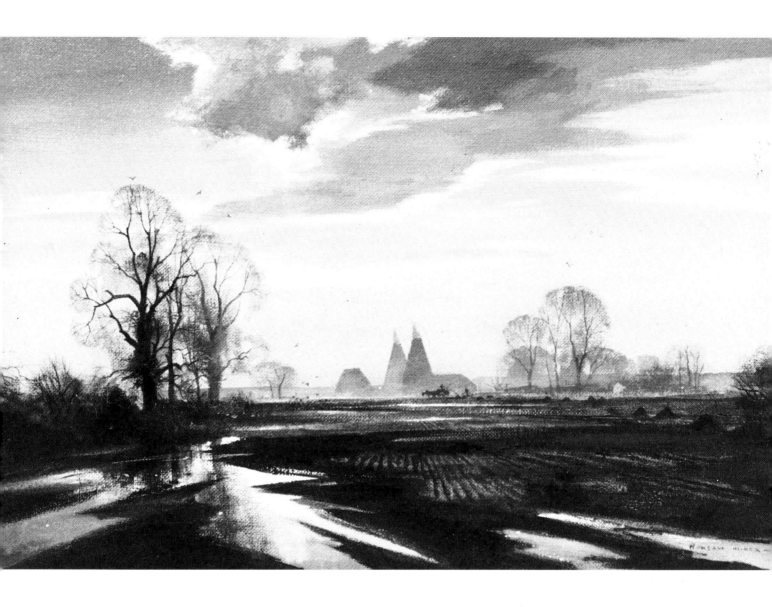

Aerial perspective At this point look afresh at examples of the work of the masters of watercolour painting, and note the constant use they make of aerial perspective in the composition and execution of their pictures. One cannot help being struck by the fact that they seem to select the kind of subject that lends itself naturally to this kind of simple and effective treatment.

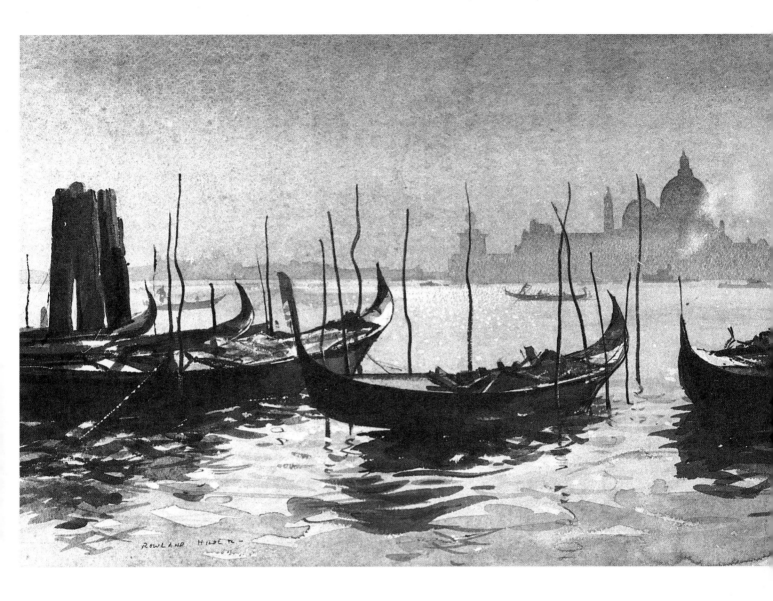

One of the basic rules of tone painting is that light tones appear to recede into the distance, and darker tones to come forward; this follows a basic principle in nature. Now study the drawing above. You will see that the gondolas were painted in dark tones whereas the buildings appear to recede into the distance because they are lighter in tone. This principle is called 'aerial perspective'.

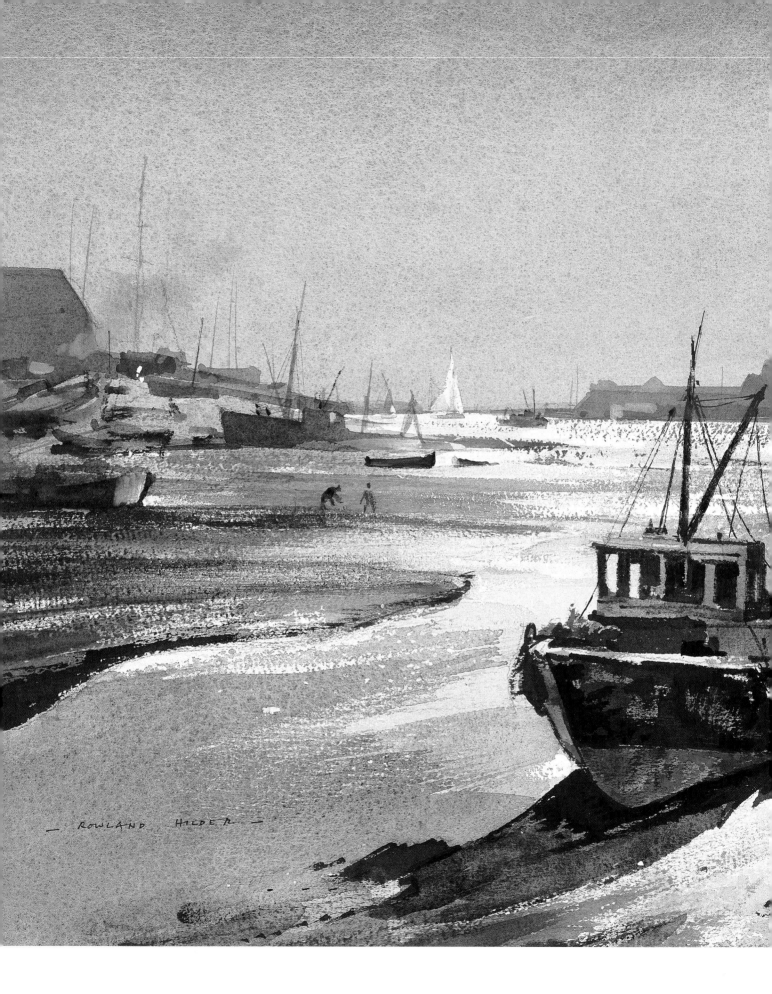

ROWLAND HILDER

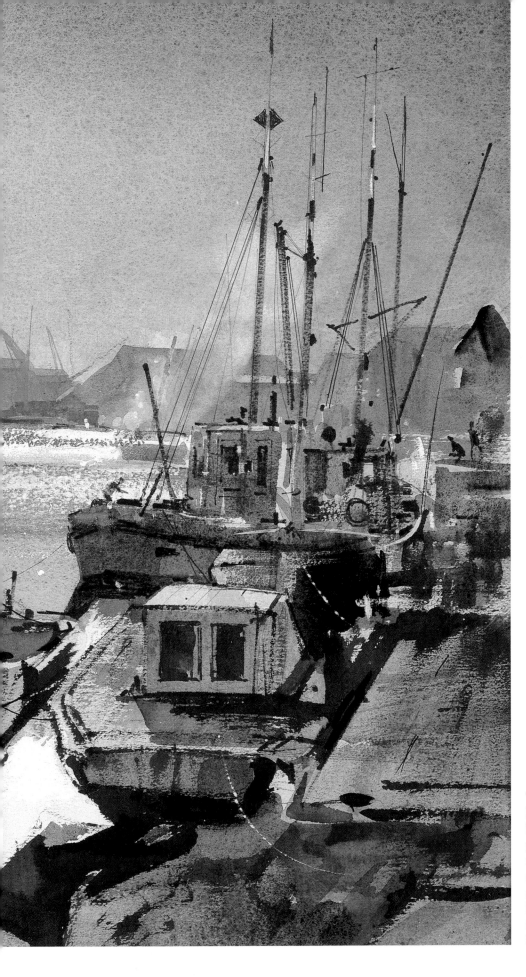

The sketch made on location using the same basic palette as in the previous sketch reproduced on pages 38 and 39. This sketch demonstrates the use of light, cool tones to convey the distant boats and buildings.

The tone key

There are a couple of simple aids that will help you to grasp the idea of painting by tone values. The most useful is perhaps the Claude mirror. This is made by painting a piece of plain glass on one side with black paint. I have made one by taking a small unwanted picture frame and painting the inside of the glass with black paint. A small piece of black perspex would serve admirably. The effect of the Claude mirror is to give a reflection of reality in a lower tone key. I strongly recommend you to try the experiment of viewing nature with the help of the mirror. With its help the most unlikely looking subjects reveal themselves as excellent material.

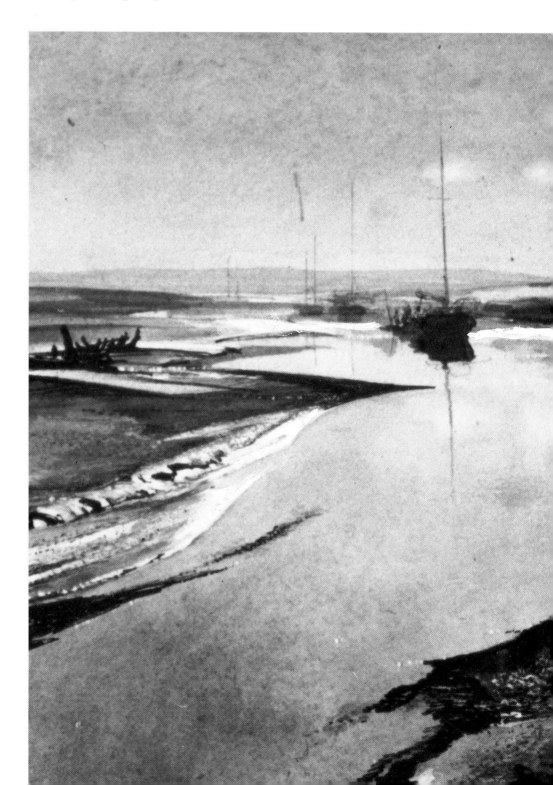

This illustration in monotone, together with the colour sketch on pages 46 and 47 overleaf, tries to show the effect of light and dark shapes against a simple background of sky and water.

Another way of introducing the beginner to the conception of relative tone values, is the use of several pairs of dark tinted sunglasses. I know of an instructor who advocates viewing the subject first through four thicknesses of tinted glass in order to place the lightest tones, then removing one thickness at a time to establish subsequent degrees of depth.

Whatever the method, the aim is to gain understanding of the process of painting, to see potential subject matter in terms of tone, and to learn to paint in tone as a prelude to beginning to paint in colour.

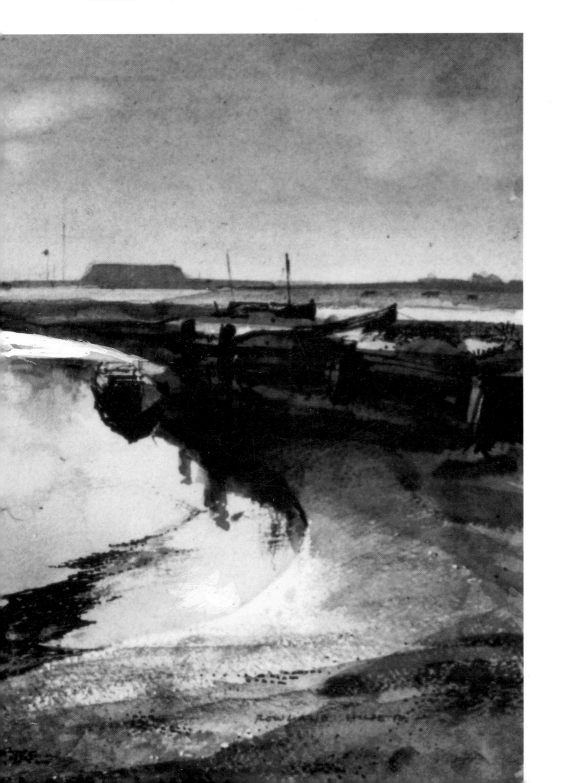

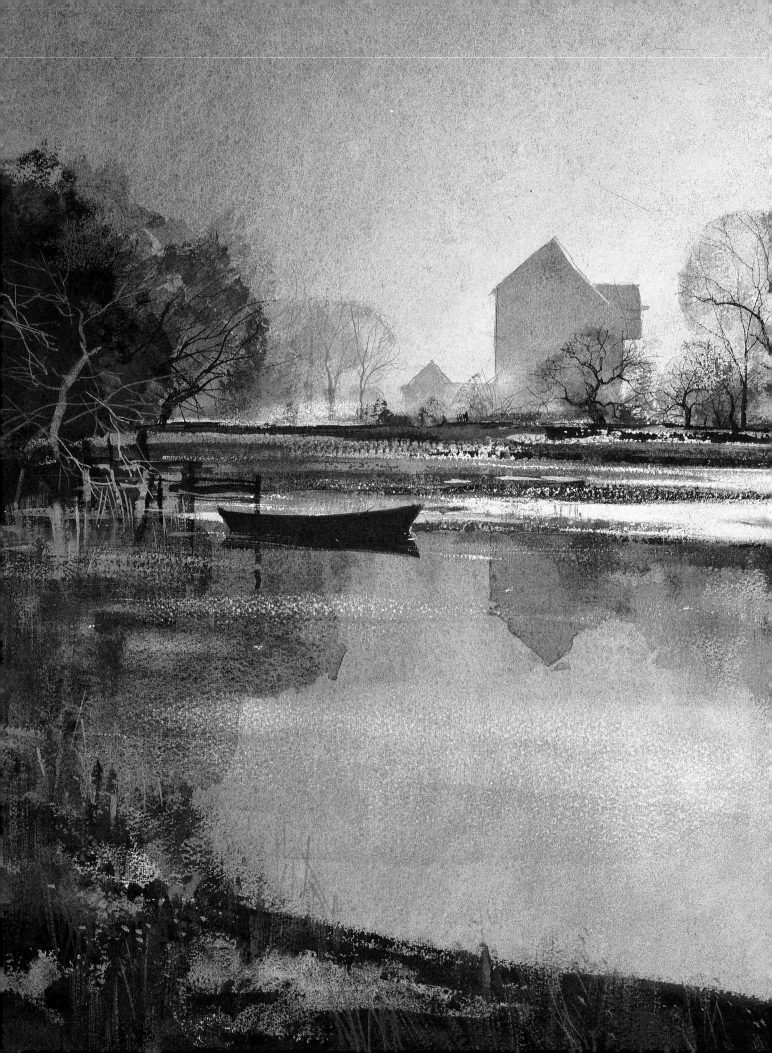

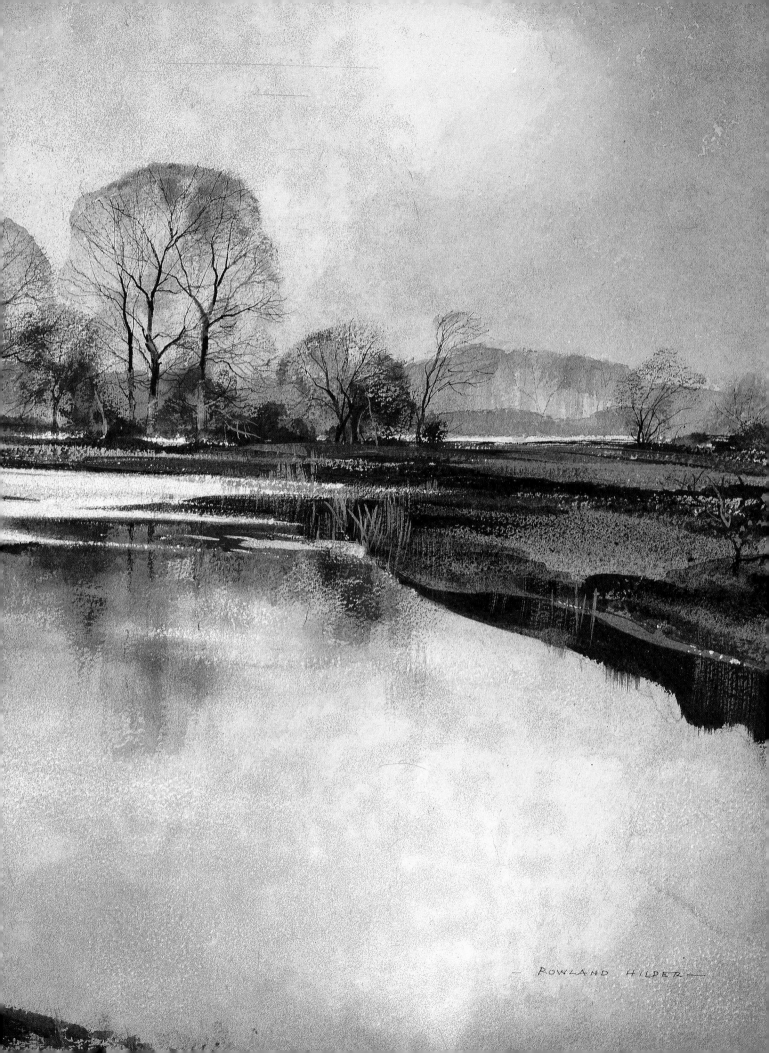

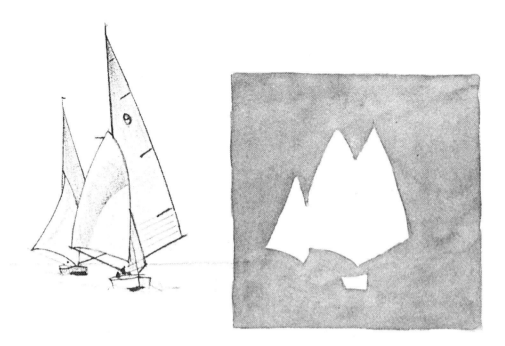

Stencils and washing out

Early textbooks on watercolour painting made a feature of the technique of washing out to achieve white and light areas. It should, however, be borne in mind that the early watercolour painters made their own colours. They carried their pigments in little glass jars and rubbed out the colour on a small piece of ground glass, adding gum arabic as required. By using this method, it was possible for them to adjust the amount of gum to suit the nature of the painting on hand. If, for example, they wished to make a deep tone appear richer and more intense, they added more gum, particularly in the dark passages. If, on the other hand, they worked with a view to washing out certain areas, they would reduce the amount of gum so that the colour could be more easily washed away when dry. Thus it was possible for them to wash out even fine lines with a soft sable brush. Painters today buy and use ready-made colours in which the gum content is constant. With present-day watercolours, washing out a fine line with a soft sable brush is not a practical proposition, as the colour when dry becomes fairly firmly fixed. A more drastic technique of washing out is therefore required to obtain anything like a pure white. There are, however, one or two possible ways of doing this. Suppose you wish to retain the quality obtained by free rapid painting, while at the same time having in the picture certain passages which require greater detail and finish. These two requirements present a problem of contradictions. You cannot, for instance, paint a free, vigorous background using bold brush strokes and at the same time paint around delicate detail. But the stencil washout technique can help you to overcome this difficulty.

Imagine that you are painting a beach scene. You want a broad, loosely painted background of beach, sea, rocks and sky. Yet you also wish to include well-finished figures sitting on the beach. To achieve this you first paint the background freely to your satisfaction. When this is dry, draw your figures on an overlay of tracing paper.

Having satisfied yourself that your figures are correctly drawn and placed, lay a piece of tracing paper over them and trace their outline shapes. Now cut out the shape of the figures with a fine stencil knife. Lay the stencils thus formed in the correct position on the picture and proceed to wash out with a soft damp sponge. Do not get the sponge too wet, or excess water will creep under the edges of the stencil. Sponge away from the edges of the stencil, working towards the centre of the area to be washed out. Be careful not to rub too hard and so damage the surface of the paper. Allow the paper to dry. You will then be ready to paint in the figures on the washed out white areas.

The use of stencils will, of course, produce a clear washed out area with fairly hard edges. You may, however, want a graduated or soft effect, as for example when painting a sky or the mist around mountains. These effects can often be successfully obtained simply by using a sponge without stencils. First slightly damp the area to be washed lighter, then sponge lightly until the desired effect has been achieved.

If you require small areas of crisp, clean white and wish to avoid the use of body colour, you may find it useful to use a sharp pointed penknife. David Cox used a knife most effectively to scrape away the white shapes of sea gulls seen against the deep toned storm clouds, and again to capture the effect of white caps on a rough sea. You will find that you can get a fine, delicate, white line by using a sharp pointed stencil knife – fine enough to indicate light tree branches or the rigging and ropes on boats.

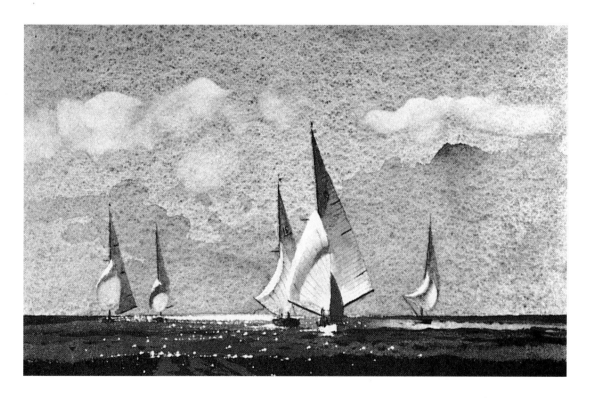

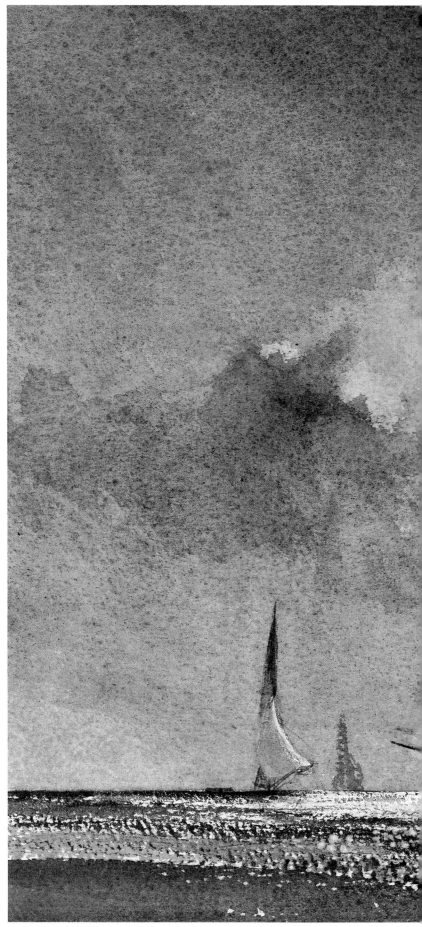

This sketch used both stencil and wash-out technique as described on pages 48 and 49. Ordinary adhesive masking tape was used to mark the horizon. Lighter clouds were gently sponged before the background wash was quite dry. Additional cloud shadows were added at the same time. The rough texture of the sea was obtained by a very dry drag of a large brush over the rough surface of the paper. Later the area was subjected to some rough treatment when dry using a sharp stencil knife.

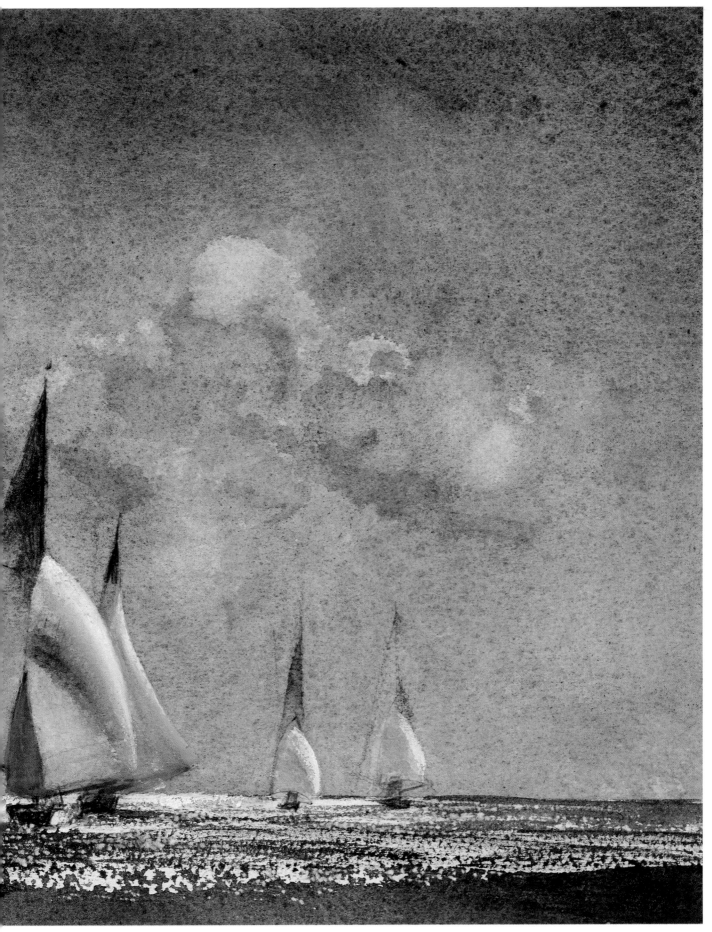

Sky study

Early instructors in the art of watercolour painting used to urge students to paint at least one sky every day of the year. If you did two or three a week, you would have the experience of doing over a hundred in a year, and you would then be able to look at a sky and see it in terms of the medium.

The painting of skies makes an ideal exercise for developing certain facets of the watercolour medium. With this subject you are not unduly worried with problems like drawing or perspective, so you are free to concentrate on such problems as finding the correct sequence of washes, the tone and colour key, the simplification of patterns and the quality of the washes. As skies are seldom static, you can begin to feel free from the topographical aspect of painting. Select the essential features of the subject and simplify. In this way, you will begin to develop a freedom of style. Moreover, it is relatively easy to find a sky to paint at almost any time of the year, simply by looking out of the window.

When painting a sky in watercolour, you will be very much concerned with the problem of applying your washes in correct sequence. First you should aim to see the sky in your mind's eye as a series of flat patterns of tone and colour. Since it is almost impossible to join the two washes at a given line without either overlapping or leaving a gap, it is essential to plan the painting to ensure correct under-painting procedure. When planning, for example, do not feel that you have to copy every kind of ragged cloud edge. Try to understand the simple basic principles and paint the essential features. Don't embark on the finished watercolour until you have a clear idea of how it should look and how each phase of the work should be rendered. Don't feel bound to persevere with a watercolour that has clearly gone wrong. Don't hesitate to abandond it and make a fresh start. The development of a new principle is more important than the value of an individual sketch. Finally, don't have a conscience about using body colour or sponging out or using any other device that will help you to achieve the result you want.

Masking medium

One of the greatest difficulties in watercolour painting has always been the white areas. To achieve a pure white you normally only have to leave the paper blank and paint round the space. With a complicated subject, this can become almost impossible. To overcome these difficulties, painters have tried to find a material that will resist the watercolour wash.

The sculptor Henry Moore used a system of drawing with an

ordinary paraffin wax candle before applying his washes. As candle grease resists watercolour, the paper remains white in the areas touched by the grease. When used on a rough watercolour paper, the candle grease technique produces a granulated, broken white texture akin to crayon work. It is, however, impossible to use this method to mask an even flat, area with clean, well defined edges. To overcome this difficulty, some painters have tried heating the candle in a tin lid so that it melts, becoming a fluid; it is then brushed on to the paper. The technique works very well, and you can get fine, delicate, white lines by painting on the liquid wax with a fine brush. The chief difficulty is that the wax becomes invisible when applied to the paper, so that it is impossible to see where you have painted it.

This problem can now be solved by using the rubber solution masking medium. It is now generally available at most art suppliers, and has two main advantages over the paraffin wax method. First, as the medium is tinted, you can see where you have painted it. Second, the rubber can be easily removed when dry. Masking medium is a colloidal suspension of rubber solution in water, so water can be used as a thinner. As the medium must be painted on to the paper before washes are applied, careful planning and a very clear idea of the picture you mean to paint is necessary. To begin with, you might consider painting your first pictures using this medium from the chalk and tone sketches drawn on tinted paper. By doing this you will know in advance the extent and position of your white areas and the general tone scheme.

Let us imagine that you have stretched your paper and made an initial line drawing using, say, a brush and Indian ink. You must now decide on your areas of white, which should be painted with masking medium. You must then wait for the medium to dry. Apply the first wash of colour, say a background grey, over the whole surface of the paper, brushing fearlessly over the masking medium. You may now decide that you wish some areas of the grey background to remain. If so, cover with masking medium before applying further washes. When you have finished the painting and it is quite dry, remove the masking medium simply by rubbing it with the finger. You will find that it will peel away quite easily.

A word of warning about the use of brushes in masking medium. Having used a brush in the medium, immerse it at once in water and wash out later in warm soapy water, gently rubbing the hairs with the fingers to remove all traces of rubber solution. If you find that some of the rubber is still sticking to the brush, you can remove it with a little lighter fuel.

Figure 1 The intended light areas of the sky were painted with masking medium. A strip of adhesive masking tape was placed along the intended horizon. Spots of masking medium were added to the foreground water.

Figure 2 A simple wash of blue grey watercolour was painted over the sky area. A deeper blue grey wash was added to represent the foreground water.

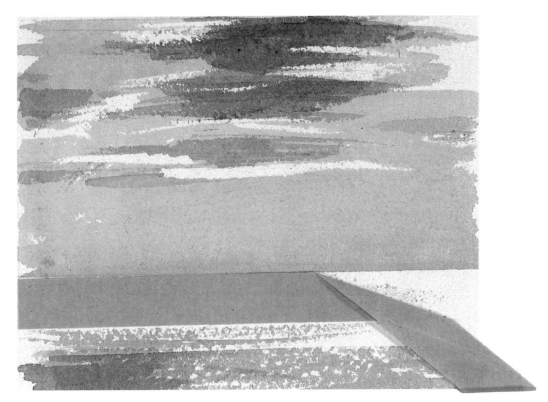

Figure 3 When the background wash was dry additional darker toned cloud shades were added. When dry the masking medium was removed by rubbing with a finger. The masking tape was removed to reveal the unpainted white horizon.

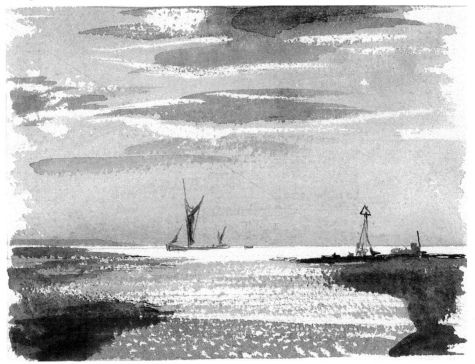

Figure 4 Additional watercolour tones and drawing were added to complete the picture. Some details were retouched using a sharp pointed stencil knife. See pages 108 and 109.

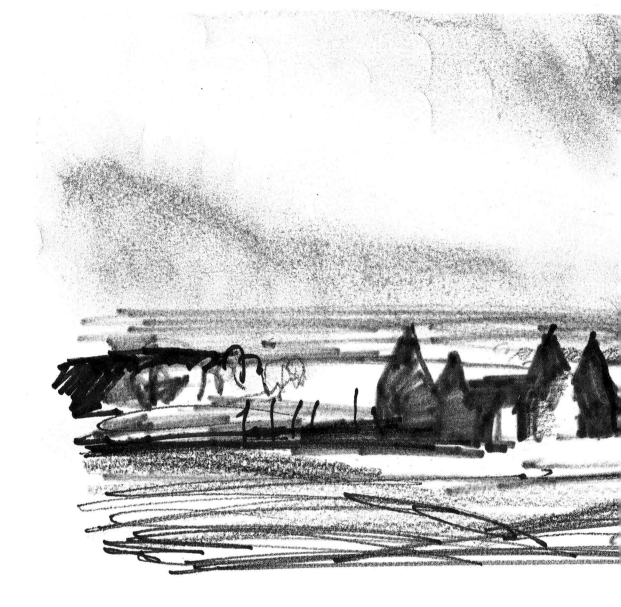

Counterchange Counterchange is the art of drawing or painting dark shapes against light, and light shapes against dark. For example, the light base of the trees in the picture overleaf stand out against the barn while the dark upper branches are silhouetted against the snow.

I recommend you to go through a number of small black-and-white reproductions of the work of the masters, analysing how they use the counterchange principle in the composition of their works. The best way to appreciate this fully would be to make small free-hand sketches from the pictures, reducing the main items to a simple counterchange scheme. I am sure that you will be astonished to see how most of the important pictures make very good sense when reduced to a simple black-and-white counterchange arrangement.

Having done this and become familiar with the principles of counterchange, you will begin to see new patterns in nature. It is astonishing how often in a landscape, objects seem to be set against one another in sharp contrasts of tone.

Imagine that you are standing on a hill top, viewing a large vista

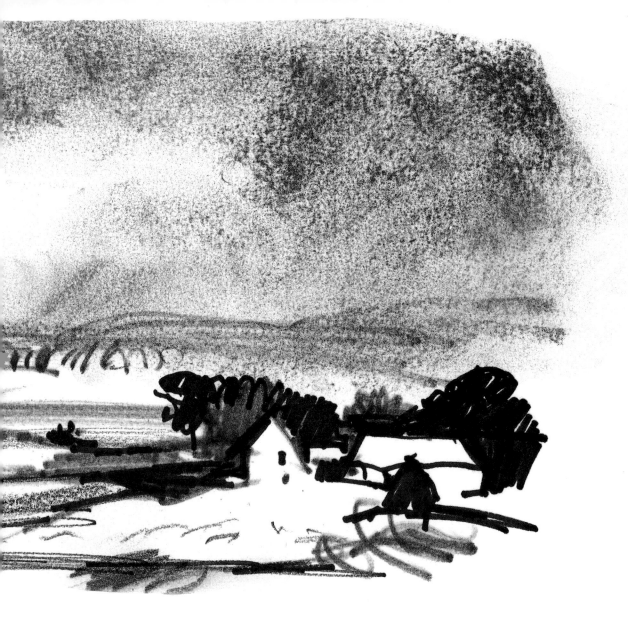

of landscape on a bright windy day. Dark cloud shadows are travel-
ling over the forms of the landscapes. At one moment the sun lights
a group of trees and buildings, revealing them as a series of light
shapes contrasted against a dark background of cloud shadow. In
another part of the view the reverse is happening: a whole portion
of the countryside has been thrown into shadow and now appears
as a dark mass, its upper edge silhouetted against a lighter
background.

Having seen this in pictures and then in reality, you will become
increasingly aware of these contrasts of tone, and will begin to
appreciate that the principle of counterchange is a reflection of one
of the basic principles of nature. Turner was a master of the art
of counterchange. In his painting of the Royal Naval College at
Greenwich, he had the problem of painting the two domes of the
building. He achieved a most exciting effect by showing one dome
in strong sunlight and the other as a dark silhouette, overcast by
a passing cloud shadow.

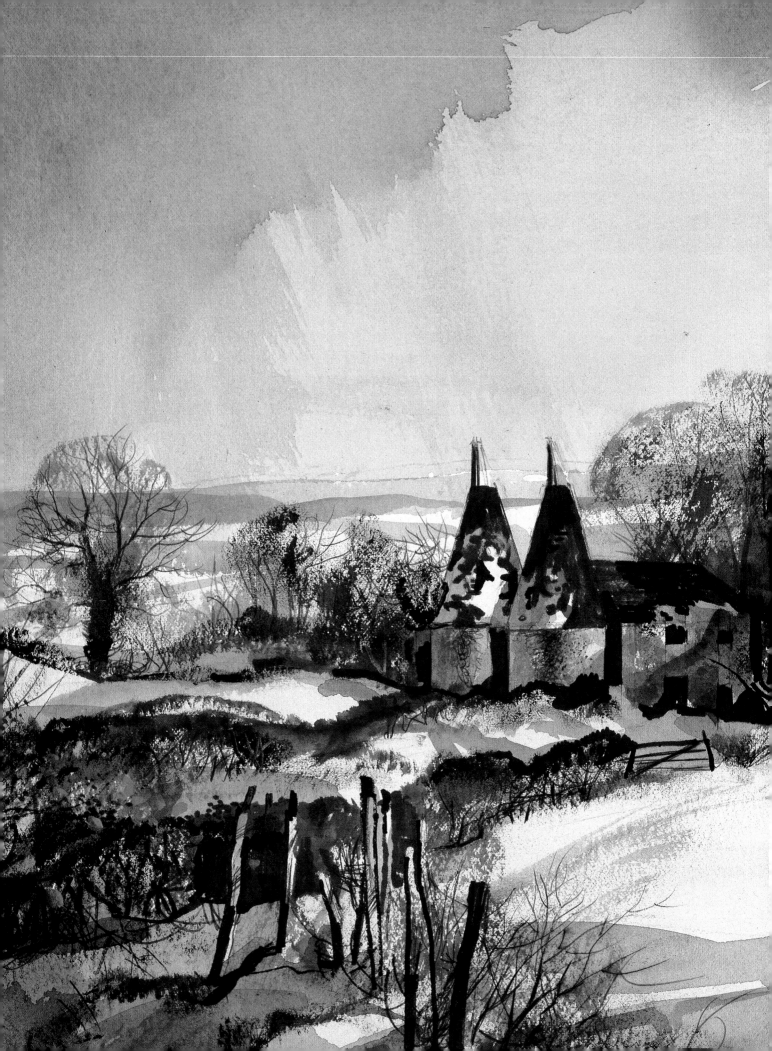

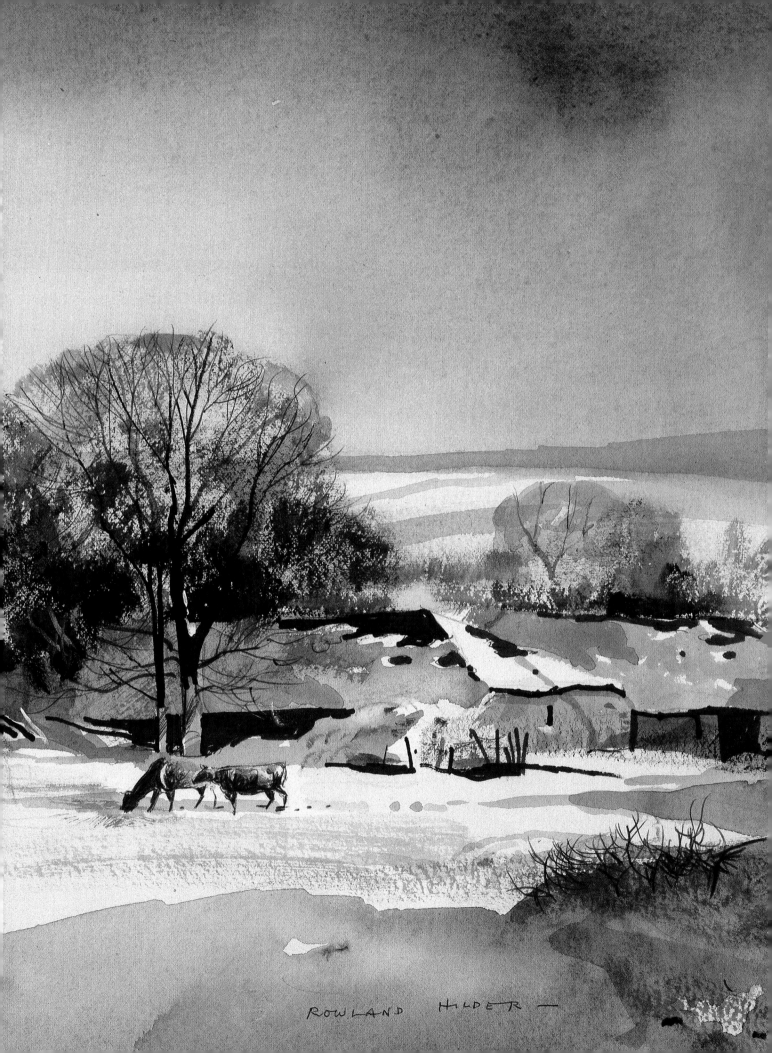

ROWLAND HILDER —

Texture

Imagine you are still standing on a hill looking over a landscape. You will of course be aware that the various objects in the landscape are composed of different materials. Some appear to be smooth, others rough. For example, a hedgerow is made up of countless branches and twigs. If you tried to walk through such a hedge, you would scratch yourself and tear your clothes. Yet you could walk unharmed through the mist which hangs over a field in the valley. These two objects have a different feel or texture. Can this texture be conveyed in a painting and if so how can it be done? We can convey the impression of changes of texture to a point by simulating the effect we see and feel in nature. For example, a line can appear to simulate wire or sharp objects. Faint graduations of wash can give the impression of cloud, smoke or mist. Thus if we were to set hard lines depicting trees or bushes against soft graduations of tone that simulated, say, a rainy sky, we could convey by such a contrast of texture something of the essential mood of the scene.

We can also convey the texture of a field with its mixture of colours by dragging a semi-dry brush over the rough surface of the paper, taking one colour over the other to give a speckled multicoloured effect. We can also make use of precipitating colours to convey the feeling of foliage or of grass on a hillside in the middle distance.

One can simulate the look of a crumbling wall by dragging one colour roughly over another, or even by scraping the surface of the paper. In making use of such devices you must, however, be careful to avoid the temptation of indulging in an effect for its own sake. Part of the charm of a good watercolour is that it gives one the feeling that it has been done spontaneously with ease and grace. It is only too easy to make a painting look mannered and laboured. Make use of textured effects by all means if they add to the beauty and feeling of the painting. I have seen watercolours which have been ruined because everything in the picture has been given a 'texture' without thought of feeling or expression.

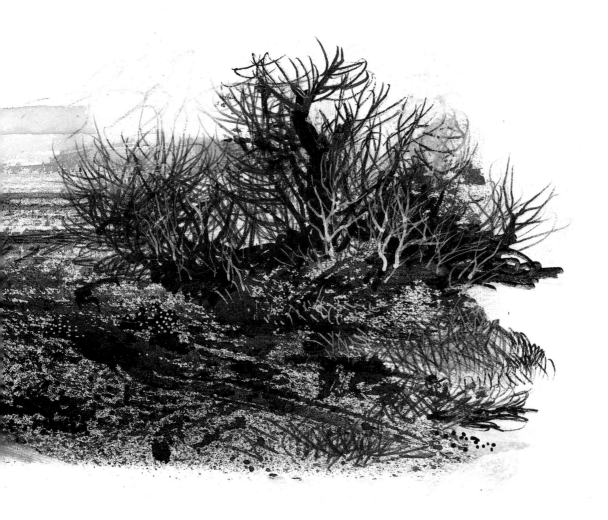

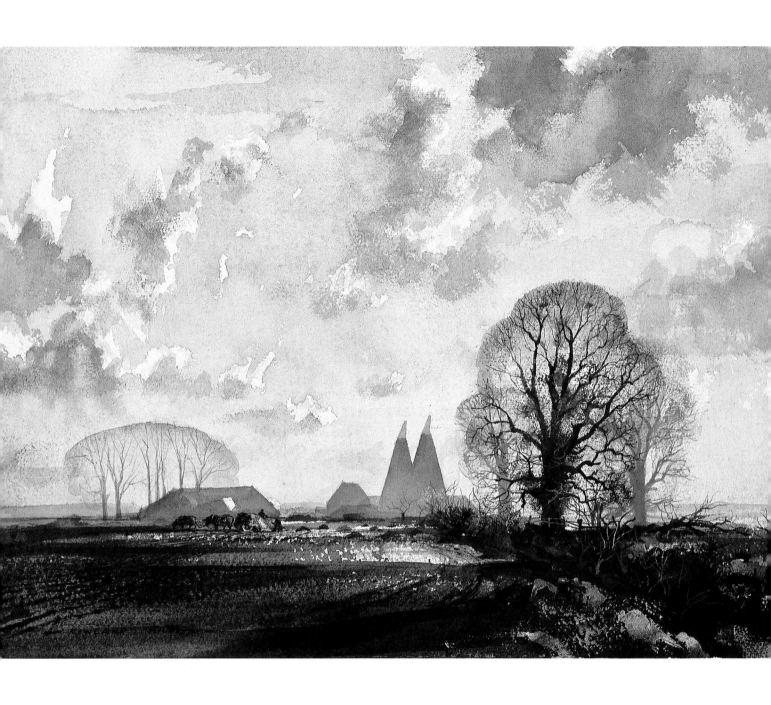

This picture shows the winter sun shining through the tangled growth of hedgerows and bare trees across the rough granulated texture of the glistening ploughland.

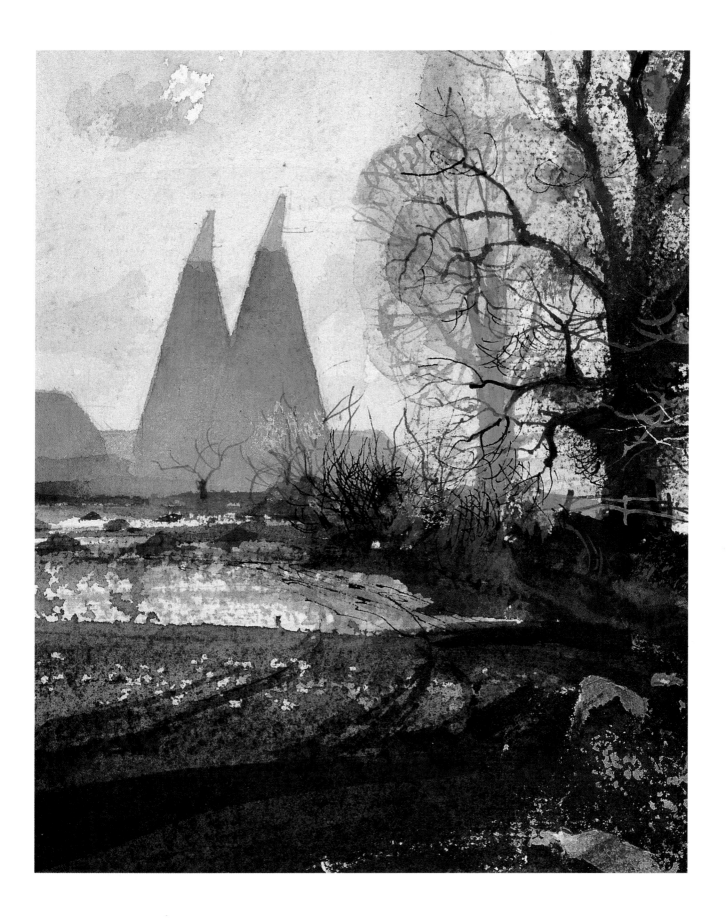

63

Trees in the landscape

The painting of trees in a landscape presents a number of difficult problems. When you look at a tree you see a wealth of detail. There are the large boughs, numerous branches and thousands of twigs and leaves. To attempt to paint even one tree in full detail would require much time and patience. Constable did attempt this very difficult feat with success, and one can see his detailed study of a single oak tree made in lead pencil at the Victoria and Albert Museum in London. The execution of such a careful study must have contributed to his great understanding of the structure, and was undoubtedly of great use to him for future reference. However, the fact remains that today his small sketches are considered his most exciting and interesting works. In these sketches he paints trees in the simplest possible way, making use of broad flat shapes of tone and colour. This technique of direct painting conveys the general impression of the scene with great charm and conviction.

When we consider the watercolours of Cotman, we see that he treated his trees as a series of simple flat shapes and patterns, and Bonington and De Wint used much the same method. At times De Wint made wonderful use of the rough texture of his paper, dragging the colour over the surface in a way that conveys the impression of countless leaves without giving the feeling that the sketch has been laboured. While there is no such thing as a ready-made formula for the painting of trees, a study of the sketches by the masters of watercolour painting will suggest ways of solving various aspects of this very difficult problem.

When about to paint trees, you should ask yourself whether you wish to make a portrait of a particular tree, or whether the tree is to be a factor in the general landscape. If the latter, then it should be painted simply and clearly as a pattern of tone and colour. The

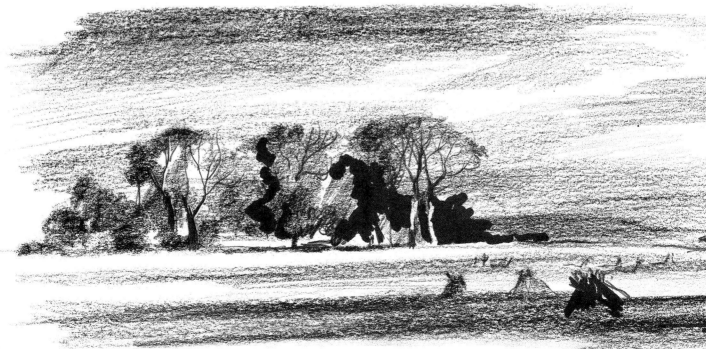

tree should sit naturally in the landscape and look part of it. If this is done successfully, it will look convincing, even if it is only indicated by a few bold strokes of the brush.

Let us imagine that you are contemplating a wide open landscape. Observe the relative warm and cold colours. Note the effect of atmosphere. Remember your earlier exercises in aerial perspective; note how this works in nature and see how the more distant objects appear to be lighter in tone. Note how the colours get slightly colder, or bluer, as objects recede into the distance. Look carefully at the shadow side of the foliage of the distant trees. You will see that they are grey and not green as you would expect. Only the sunlit side will appear green. Unless you are painting in a country where the atmosphere is unusually clear, you will find that the shadow side of trees will appear grey right up to the middle distance and that only the foreground trees begin to look green on the shadow side.

To obtain the flat tones of grey for the far distance and middle distance, you may find it helpful to use a little grey body colour, a simple mixture of black and white, with a touch of blue maybe for the distant hills. You can increase the depth of grey by adding a touch of black for the shadow side of the distant trees, increasing the depth still further for those in the middle distance. Work forward progressively from background to foreground. As you work, do not forget to view the subject periodically in the Claude mirror and discipline yourself to see the subject in terms of broad simple areas of tone.

One of the most exciting aspects of working from nature comes when you unpack and view your work at home. Only then are you able to see the result in true perspective and to see if the result of the day's work begins to convey something of the mood of the landscape that you are beginning to understand and know.

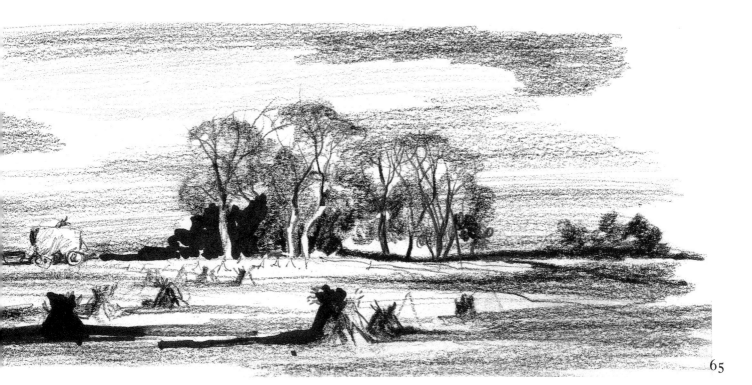

A Vista of Summer Trees This sketch aims to draw attention to certain basic principles involved in viewing a broad vista of landscape. Following the rules of aerial perspective the lighter and cooler tones appear to recede and darker tones to come forward. The shadow side of distant trees has been rendered in receding tones of cool grey while the sunlight side remains green.

Note that the shadow side of the foreground trees begins to appear green.

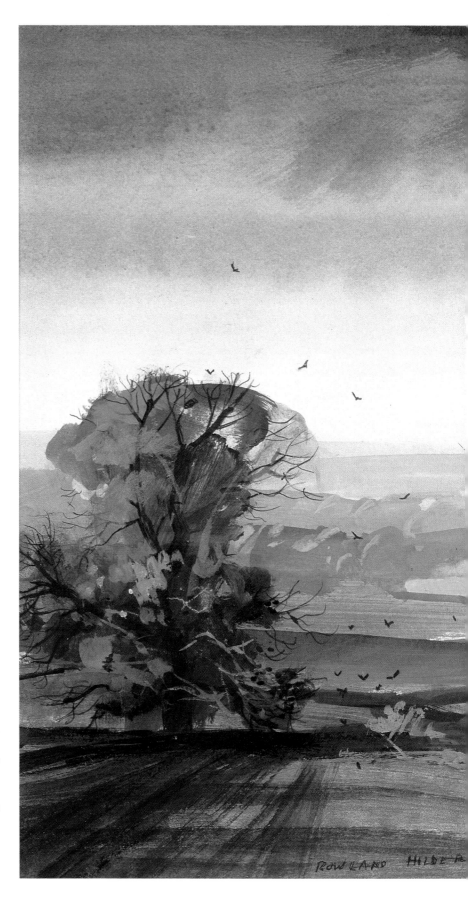

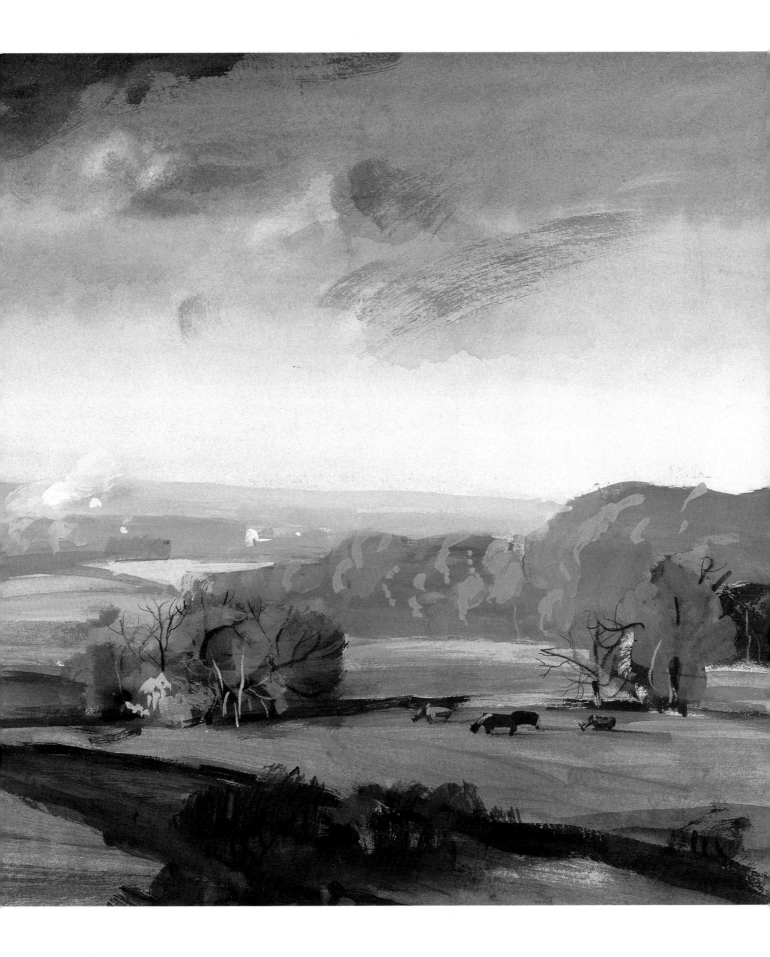

Gouache

The exercises outlined here are a development of the previous exercises in line, pencil and chalk on tinted paper. This new technique aims at combining drawing in line and wash with the addition of solid opaque colour. For painting in gouache, you need to add a tube or jar of white and black body colour to your range of watercolours.

One of the great advantages of gouache painting is that you can work on tinted and coloured papers. Choose a paper that approximates to the tone and colour of your subject, and begin work by making the initial drawing in line and adding transparent colours as before. If the main part of your subject is in tone, you can begin by painting in the largest tone areas at once. For example, imagine that you have a subject with a background of blue grey sky, and that you have already selected a suitable blue grey paper. Seen against the sky are a number of houses silhouetted against the light. The sun glistens on the rooftops of the houses after a shower. In this case you could begin by blocking in the general shape of the group of houses as a simple area of flat tone. This could be done in transparent colour. When making the wash, you should bear in mind that the colour of the paper will affect the colour of the transparent wash. Thus if the buildings are warm in colour, you would have to add a little warm colour, say burnt sienna, to counteract the underlying cool, blue grey colour of the paper.

Many students feel that it is somehow dishonest to resort to the use of body colour. As I pointed out in the introduction, there is a good precedent for using body colour in Turner's wonderful sketches made on tinted paper. Surely it would be wise to experiment with the medium to find out if it suits your temperament and requirements. You may find that, like myself, you want to be free to use both the transparent and opaque methods, even on the same picture, if the subject calls for such treatment.

On the whole the gouache technique succeeds best in smaller paintings. The medium is ideal for making quick studies and sketches, and for noting down details relating to general tone and colour and for atmospheric effects.

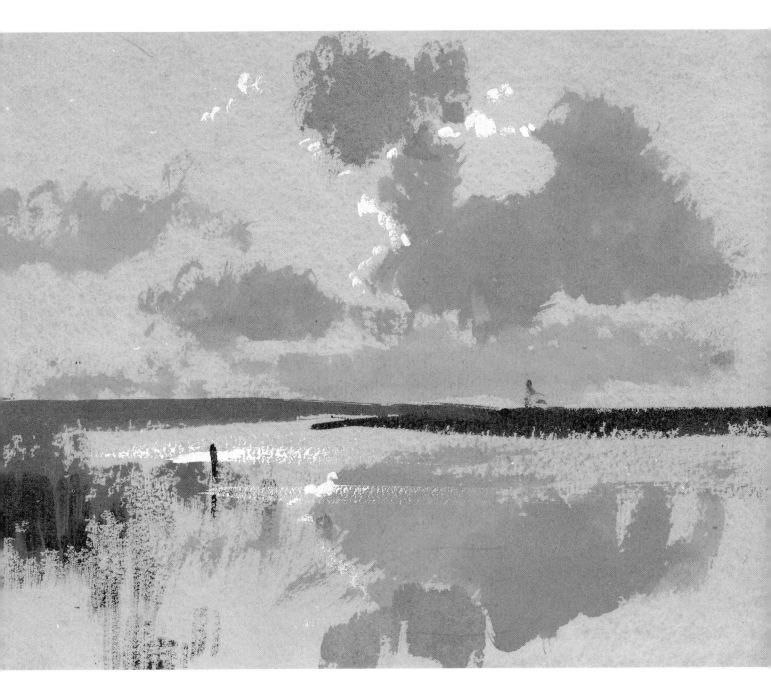

The use of the Claude mirror and dark glasses often help to reveal surprising tonal pictures. With the help of these aids the brilliant range of tones seen in nature can be brought to within the very limited range of tones available to the painter.

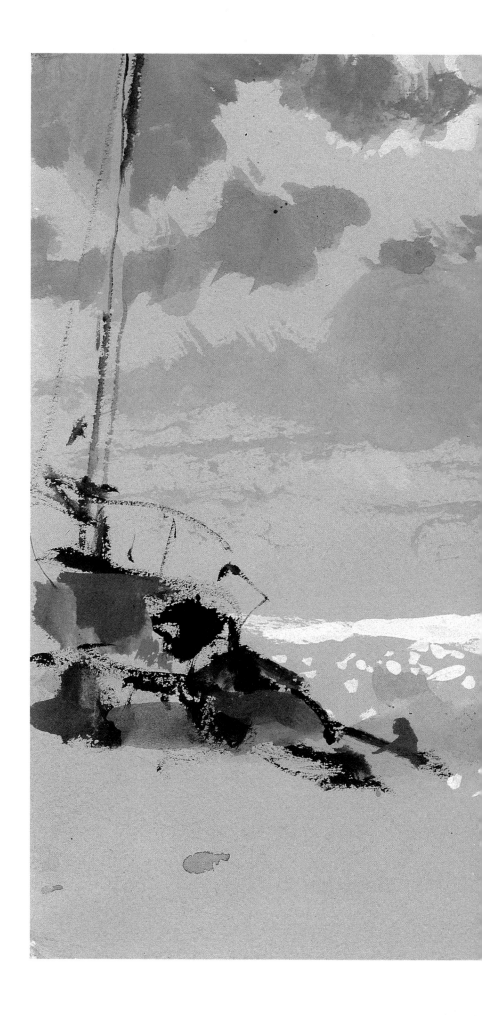

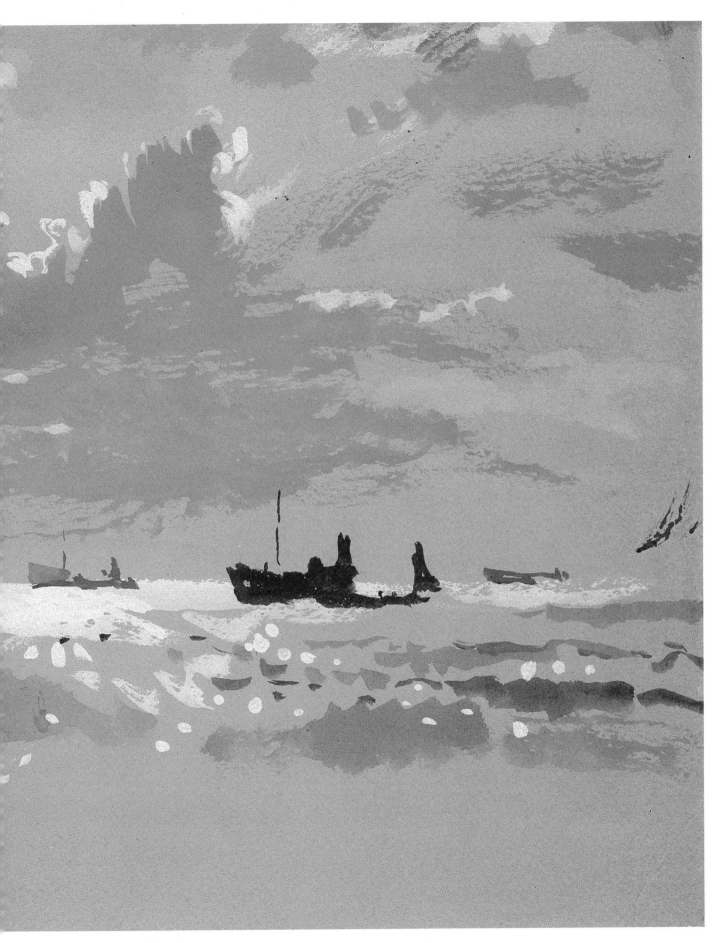

Sketching

When making sketches out of doors, try to record the broad, overall effect. Work rapidly. If you are using watercolour, have two or three sketches in hand at once. Thus the sky in one can be drying while you are drawing the trees and buildings in another. A copse on a hill may, for example be indicated simply with a broad stroke of the brush, while a plain flat wash will serve to convey the impression of the distant hills. Several sketches of the same view will capture the changing aspect of the landscape by recording the movement of passing clouds and the effect of shadows as they sweep over the countryside.

Carry a selection of coloured papers, white, cream, several shades of grey, pale blue, and a selection of blue greys. You will then be able to choose the colour nearest to the general tone and overall colour. Reduce the colour scheme to the simplest possible formula. For example, a blue grey (indigo plus lamp black) and a brown (burnt sienna plus lamp black) would perhaps convey the main tones of sky and earth, a touch of body white a cloud or a distant cottage, a touch of light yellowish green the sunlight on a field, a deeper wash of olive green (cadmium lemon plus lamp black) a group of trees – and the scene is there!

Do not become involved in the first instance with too much detail. Aim at capturing the mood, at recording the general tone and the main forms of the landscape. You are looking firstly for ideas and inspiration. The more exciting these are, the better your picture will be.

Work the first sketches on small sheets of paper, for three reasons:

1 Small sheets are easy to carry round with you.
2 It is easy and quick to cover a small sheet with a wash of colour.
3 You will be less tempted to overload a small sketch.

You will soon know if the idea works; if the work goes well, you will become completely absorbed. It can be feverishly exciting to produce sketch after sketch in rapid succession.

When you come across an inspiring subject, it is worth sketching it in a variety of ways. What you may have thought an unpromising sketch at the time may, when reconsidered at home, prove to be the one that conveys something really essential. For example, having painted a barn in some detail, you may look at it again and see the whole of the middle distance as a shape against the sky. Your next sketch may in turn capture quite another aspect of the scene – perhaps a feeling of atmosphere that you had not at first appreciated. Don't be depressed if the medium doesn't respond at once; you may need a little time to limber up, to lose the feeling of self-consciousness and to feel at ease with the medium and not afraid of it. You will then begin to feel almost part of your subject.

Sketching

Sometimes one approach will work, sometimes another. Different subjects call for slightly different treatment. One landscape will perhaps appeal because of its tone and colour, and its mood may best be expressed by a series of sombre washes of colour without any emphasis on form. Another, in contrast, may demand the expression of form together with sharp accents, and look better executed mainly in line. The tones in such a scene will be subservient to the drawing. In this case it may be better to begin by drawing boldly in line, using a stick and ink or a 2B carbon pencil, or a combination of both. Or you could try painting the main shapes boldly in wash, strengthening with line by using the carbon pencil directly on the wet washes; you will be surprised to find how easily the pencil takes over the wet wash. I am sure you will be impressed with the speed with which you will be able to work.

You will almost certainly have to do one or two sketches to find out which method works best on a particular occasion. If the work is not going well, change the method at once in search of something that will suit the mood of the moment. In spite of all the advice to the contrary, don't hesitate to abandon a sketch at once if it is not responding as it should. (In this case genius is not an infinite capacity to take pains!) Be prepared to make any number of changes and fresh beginnings. Don't get involved in trying to salvage a dud – it's more important to make the most of a good mood and to grab at anything that works than to worry about breaking a number of crackpot rules. You may well be on the point of developing a personal style!

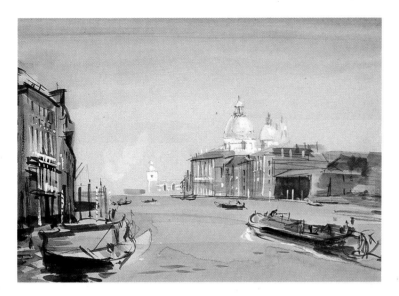

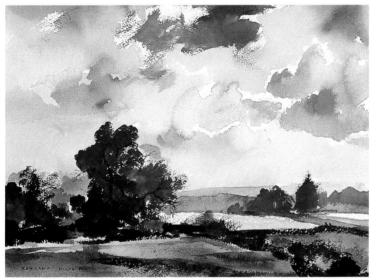

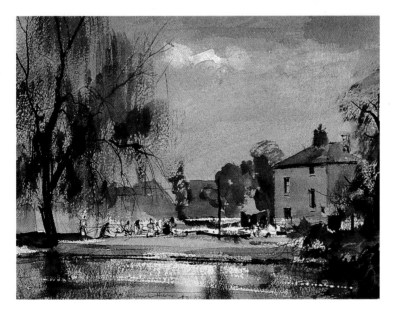

Black-and-white sketches
taken from sketch books.

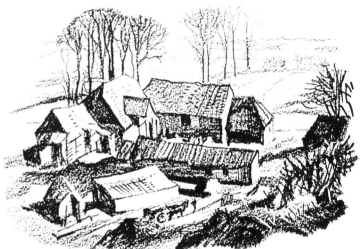

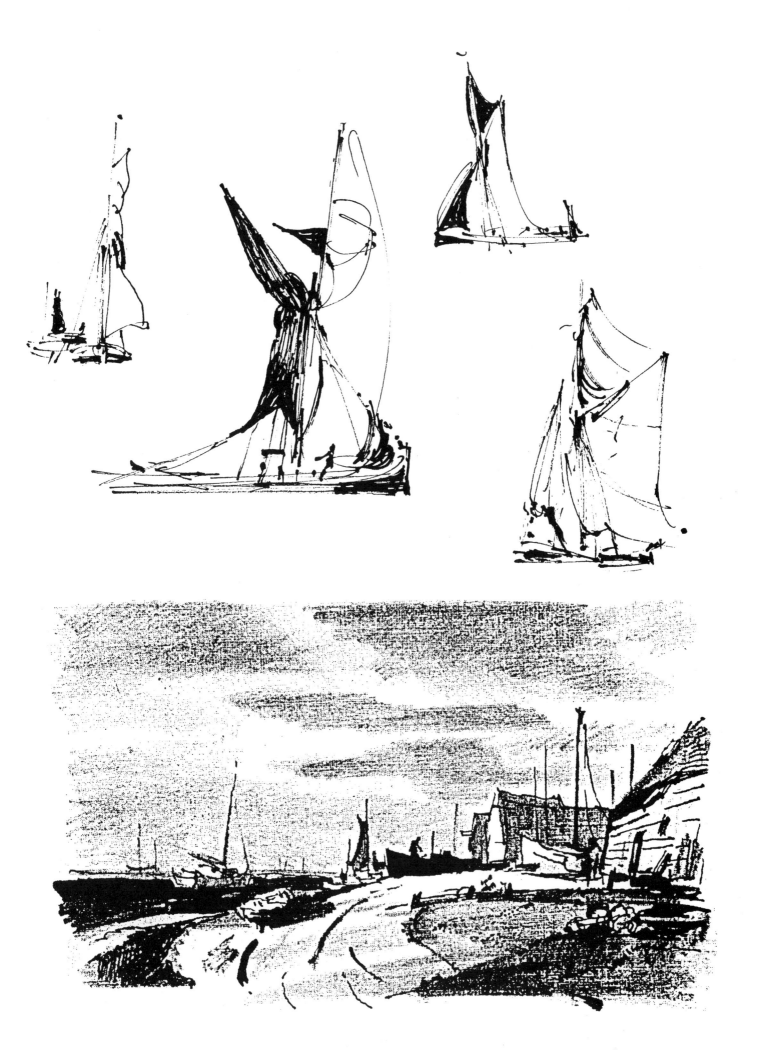

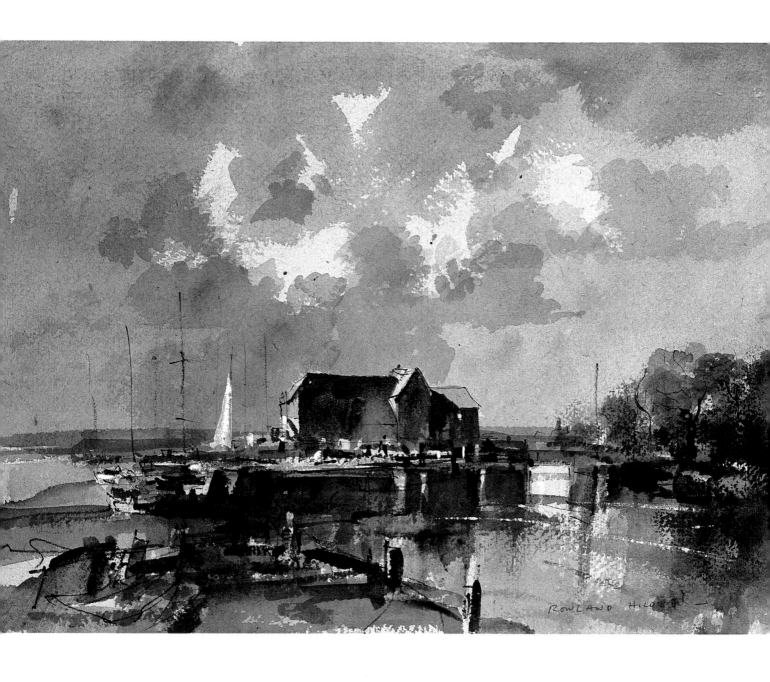

The Old Tidal Mill, Birdham Pool, Nr Chichester This is an experimental low-toned sketch based on rough sketches and notes made on location. Following a very broad beginning using charcoal – which aimed at placing the main objects – the charcoal was dusted leaving a faint image which acted as a guide for the addition of dark tones using a deep brown Rotring ink with a little added black ink to give full depth. When dry an all-over wash of lamp black and burnt sienna was added. When dry, add washes of grey and sepia to establish the full range of colour and tone. A little acrylic white was added to represent the distant sail.

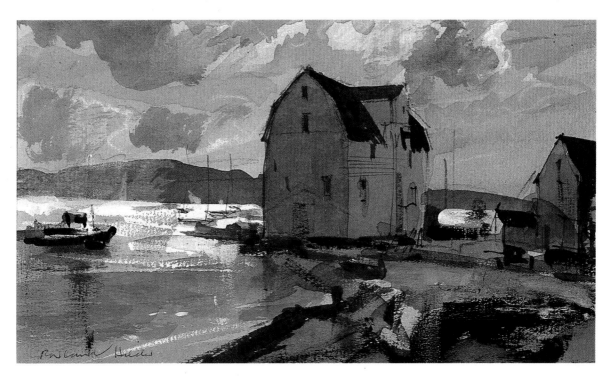

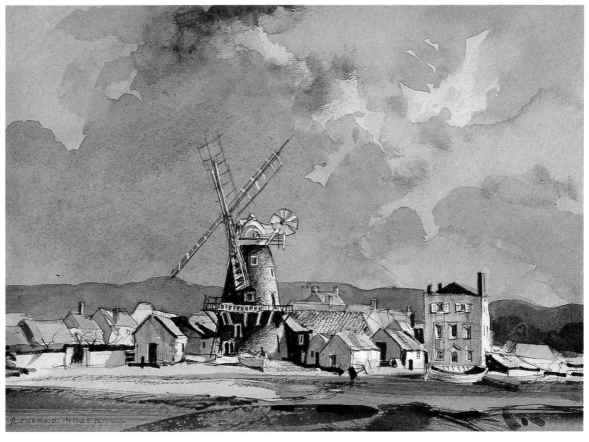

Composition

Broadly speaking there are two points of view regarding the composition of a picture. One is that the painter begins to paint and that the composition evolves by a process of selection and arrangement as he proceeds with the work. The other view is that the painter consciously makes an arrangement and seeks to make the material fit into a pre-conceived pattern. On the whole the traditional attitude was that the painter used the former method when working from nature, and that the large studio painting was carefully composed. This principle can be seen clearly in the work of Turner. Many of his later pictures have the quality of a large spontaneous sketch and seem to anticipate the Impressionists, while other works were obviously composed in a very conscious, formal manner. Braque said that when he began certain paintings, he had no idea what they would look like when finished. Other painters see in the mind's eye almost every detail of the picture before they begin to paint. Clearly one can make no hard and fast rule on this point. Each artist must

develop the method which suits him best, and I myself use both methods at different times. For example, when I receive a commission for a picture to be used as a wall decoration, or for a large picture to be used for a particular purpose, I work from a composition that has been developed from sketches, studies and notes.

Let us assume that you have collected a substantial number of sketches and studies and that you think that this material contains the germ of an idea which you wish to develop into an organised finished work. The ideal situation is to have a number of sketches featuring various aspects of the same subject. For example, one showing a promising sky, another recording an interesting lighting effect on trees and fields, and a third depicting a promising foreground. With this material you can now begin to correlate the various aspects of the scene into an arrangement that will aim at portraying what you saw and felt about the actual place.

This drawing and the one opposite are preliminary sketches for the finished painting overleaf.

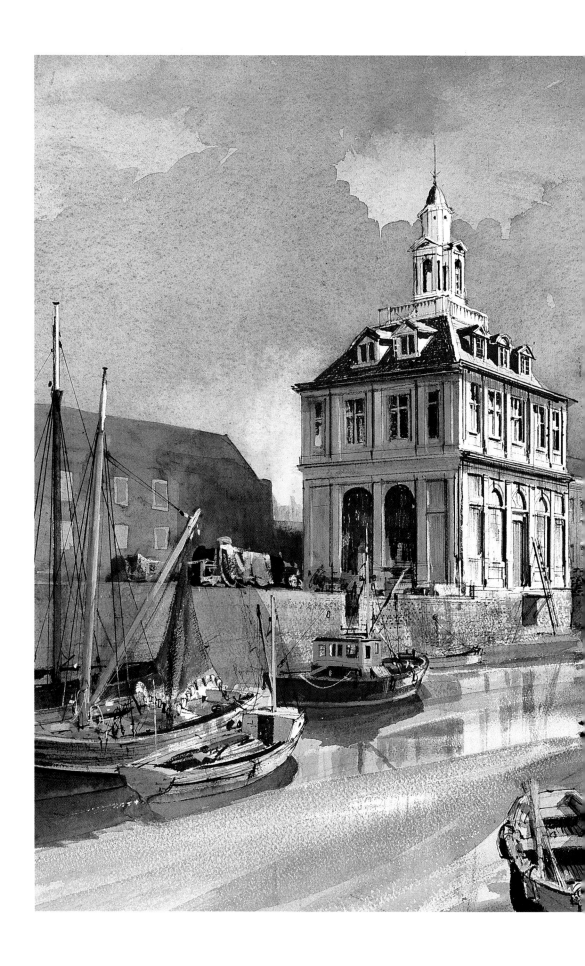

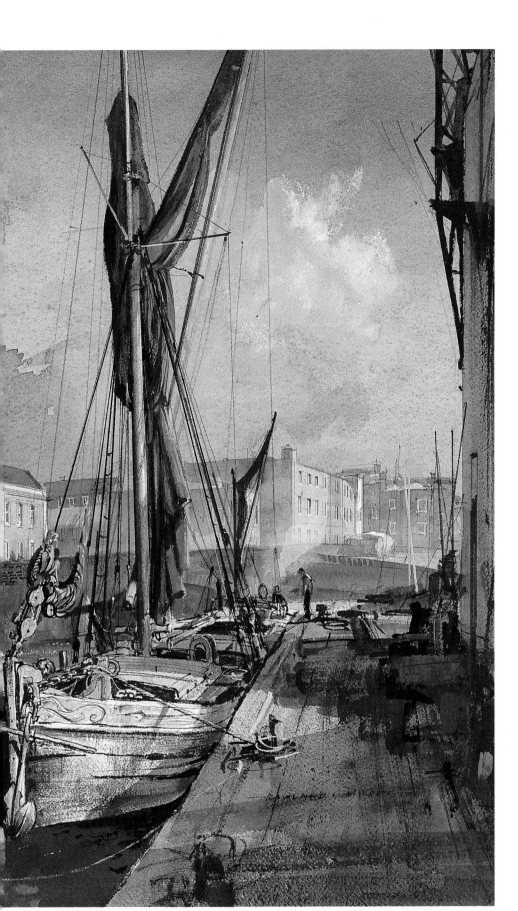

Composition

You should begin by making small composition sketches. These should be small in the first place, so that you can more easily control the basic masses of the picture and ensure that the various items in the picture read clearly. Block in the masses and main shapes in charcoal, working on flimsy layout paper. As this is slightly transparent, a fresh sheet of paper can be laid over the first attempt and enough of the original work will show through to act as a guide for further development. Subsequent sketches can now be made with a soft lead pencil, or if you prefer, a carbon pencil. The first sketch compositions need only be in monochrome. At this stage do not attempt to become involved in detail. Block in the main shapes and if these are not correctly placed, dust away the charcoal and make the necessary corrections. Do not forget the principle of counterchange – you will find that attention to this will increase the interest and excitement of the picture. Next come the colour roughs; these are a colour development of the monochrome composition sketch.

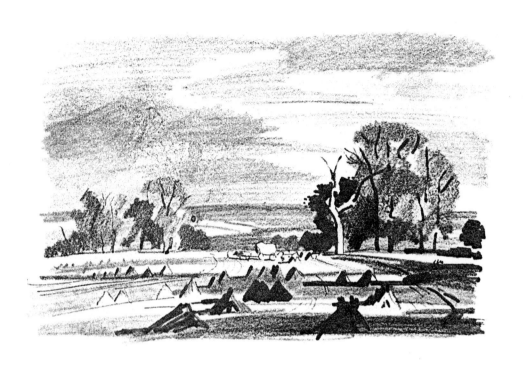

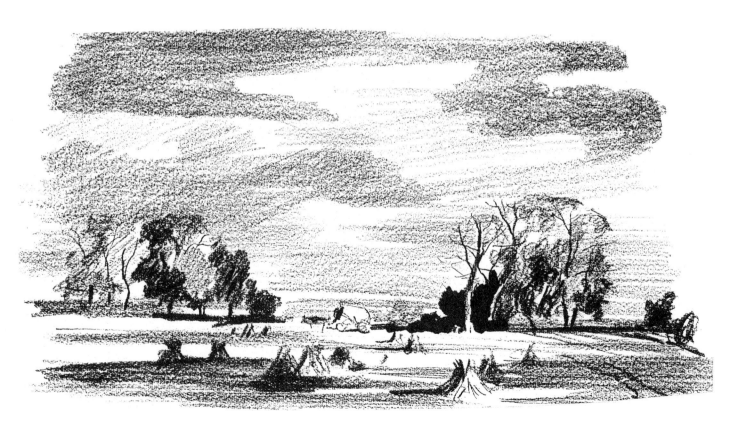

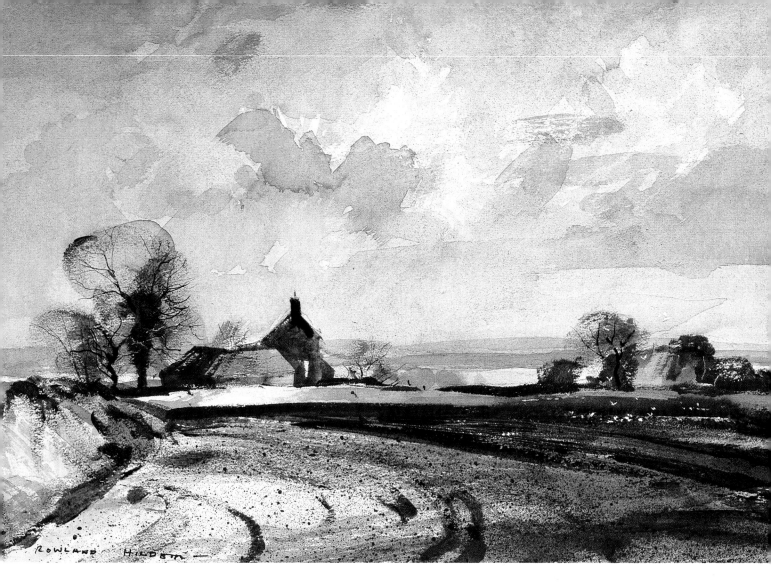

Composition

If your flimsy paper will not stand up to watercolour, you can simply trace the image through on to a stout sheet of cartridge paper. You can now block in your darks in ink or carbon pencil and proceed to apply your washes of watercolour. Have no hesitation in making corrections and adjustments in body colour or pastel. For example, you could add touches of cream or white for the lighter parts of the clouds, with maybe a touch of light blue for the open sky. Cadmium lemon with the slightest dash of virdian green will perhaps give just the right colour for the fresh grass of a sunlit field. Body-colour greys made simply from lamp black and body colour white may be useful for the distant hills and trees, with an added touch of burnt sienna giving warmth to the nearer masses of trees. You must not get depressed by an early failure – one can only hope to achieve results by trial and error. Don't be afraid of using masses of scrap paper and doing many drawings – all this can be part of the enjoyment of the work. Keep the work lively and exciting at all stages. If you find it going dead on you, begin again. Remind yourself constantly that you have nothing to lose but a little time and some paper.

Figure 1 The composition based on various sketches made on location following the lines of a few small rough charcoal sketches which aimed at establishing the general arrangement. Basic shapes were then lightly indicated in pencil. An all-over wash of burnt sienna was added, the lighter areas being dabbed away with an absorbent paper (kitchen roll). Washes of black, grey and burnt sienna were added to complete the composition sketch.

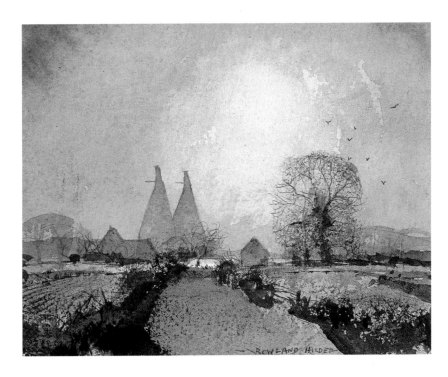

Figure 2 The small rough sketch made from memory. The basic drawing having been made in carbon pencil and fixed, using an aerosol fixative spray. Washes of black, Paynes Grey and raw sienna were added to complete the sketch.

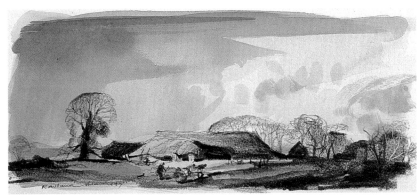

Figure 3 Snow scene, Otford, Kent. This composition was made from memory with the help of sketches made at various times on location.

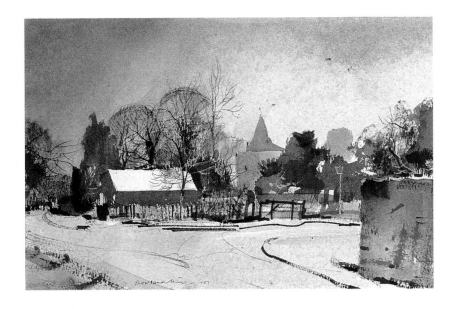

Figures and animals

Should a landscape painting contain figures? It is impossible to generalise. Obviously some are better without and some better with. Turner nearly always included figures, and if one goes through a book of his paintings masking out the figures, it soon becomes clear how much his landscapes depend on them.

Figures can be introduced and used in different ways to give life, movement and scale. For example, a tiny figure set in a wide expanse of moorland or open country will convey the vastness of the scene. At the same time, you could convey the feeling of movement and of the wind by making the figure lean forward while wind-blown trees are shown bending in the opposite direction. Remember that figures in a landscape must first of all serve the picture; they must be part of it and not just a casual addition. A figure that is too large in scale will dominate the scene and create a conflict of interests. If you feel that you want to paint a figure that is interesting in itself against a landscape background, then you should make up your mind whether the picture is mainly about the figure or about the landscape. If the figure is to dominate the scene, then the landscape should be painted in simple broad tones so as to make a suitable background setting that will add to and not detract from the main interest.

When you are sketching out of doors, it is hardly likely that a figure will be waiting for you in just the right place and in the right pose. Therefore if you wish to add figures you will probably have to do so in the studio. This is by no means an easy matter and you risk wrecking a successful sketch by making the attempt without adequate preparation. Perhaps the best way of dealing with the problem is to draw the figure on a separate piece of paper and cut it out so that it can be laid on to the sketch. This has the advantage of being flexible – you can, for example, try the cut-out in various positions. You will thus be able to see at a glance if the scale is correct, get a very good idea of the general effect, and so be able to judge whether the proposed addition does in fact improve the painting. If you are satisfied with the result, you can then lay a sheet of tracing paper over the figure and redraw if necessary. You will now be able to trace down into position ready for painting. You will, of course, be able to make these additions in body colour, but if you wish to avoid the use of solid colour, you can use the stencil washout tech-

nique (described previously), sponging the area clean prior to repainting.

When contemplating the addition of figures, it is essential to remember that it is more important to get a feeling of movement than to make a detailed accurate drawing. You can get someone to act as a model and make a study, but there is a very real danger that a posed figure can easily tend to look too static. Observe figures in an actual situation and, having made sketches and notes on the spot, then try to draw the figure from memory. Now check on this by acting the whole of the movement yourself. If, for example, you are drawing a man lifting a bale of hay on to a cart, act the movement from beginning to end. Then try to record the various positions in small, simple, movement sketches. You can draw these at first as simple matchstick figures, adding solidity and light and shade later. In this way you will be able to see which position best expresses the action and which will be best from the point of view of the composition. If you require two figures and both are engaged on the same task, you will be able to achieve a feeling of the continuity of movement by drawing one figure at the beginning of the movement and the other at a later stage. You may now like to try an experiment in counterchange, making one figure stand out as a dark shape against a light background, and the other as a light one against a dark background.

When you are out with your note book, bear in mind that you will need good foreground material, and if you see some interesting activity, make notes that will recall the movement together with information relating to clothes, lighting, etc. Also make studies of objects that can be introduced into a picture; an old plough, a farm cart or tractor, animals standing or in movement. Almost any landscape can be improved by the introduction of suitable animals, and it is useful to make sketches of them in their natural surroundings. If you have difficulty with proportion, remember to use charcoal to block in the main shapes and to record the effect of light and shade. Always remember that interesting shape and general movement are more important than dead, detailed drawing. And if you are tempted to use photographic references for your figures and animals, do try not to get involved in attempting a slavish copy. Aim to keep your drawing brisk and free.

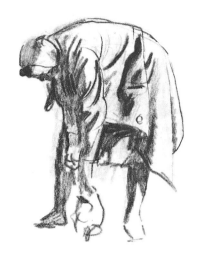

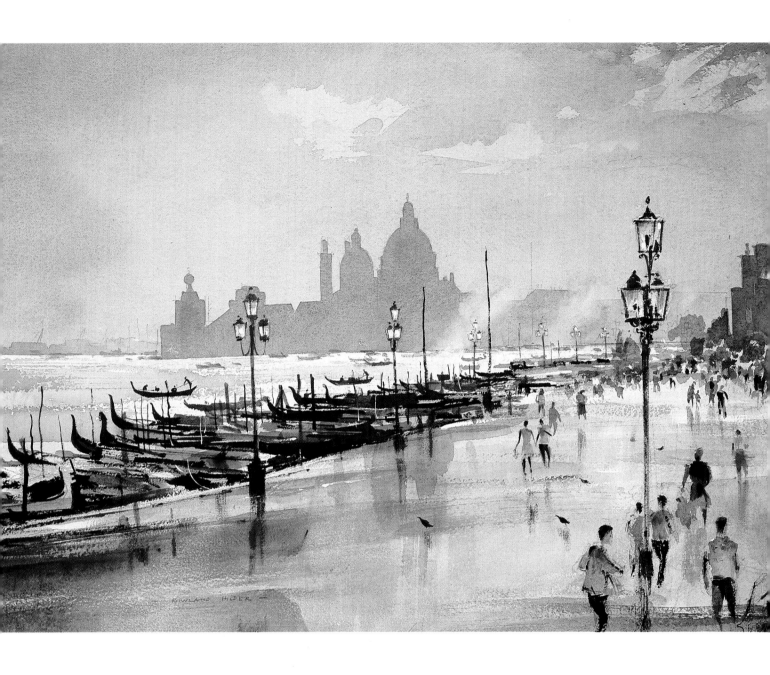

Moving figures in a landscape The Grand Canal from The Doges Palace,
St Mark's Square, Venice after a flood at high water.

This picture has been extensively exhibited and reproduced yet I have not heard
it said that the figures were badly drawn or unfinished – some without hands
or feet and so on. Yet the treatment of the figures was planned and deliberate
based on the theory that it is more effective to have figures that create the illusion
of movement rather than figures that are rigid and correctly drawn in detail. The
picture aims at conveying the feeling of a fleeting mood rather than attempting
an accurate detailed topographical documentary record.

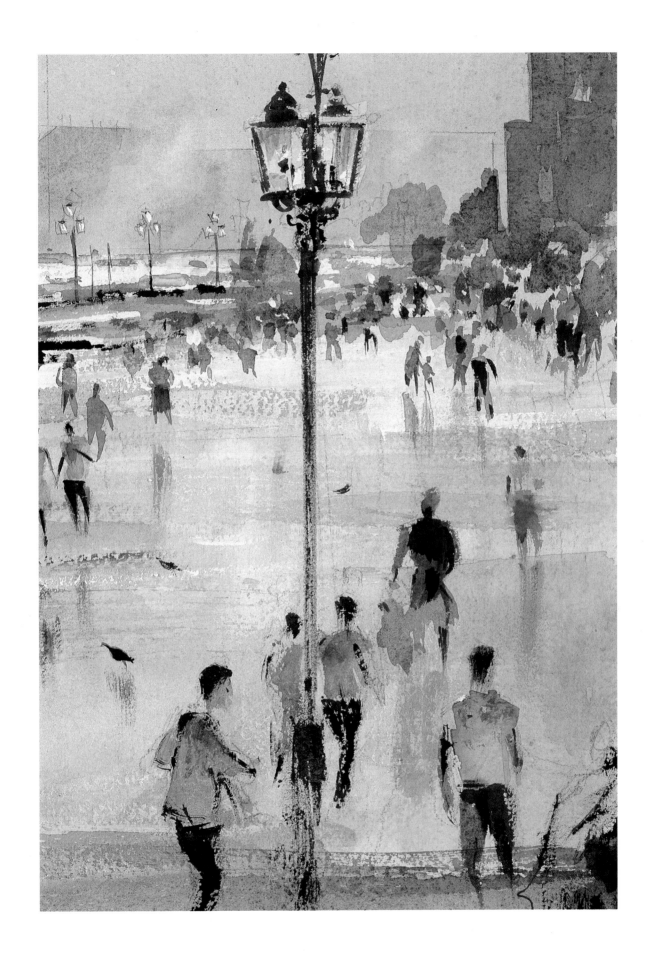

Enlarging sketches

The traditional method of enlarging a painting is by squaring up. To do this you first cover the sketch with a piece of tracing paper; it should be as thin as possible, as you must be able to see the image clearly through. You then draw three vertical lines cutting the picture area into four equal parts, and three horizontal lines likewise, producing a grid as shown in the illustration. Now draw in your englargement, using the grid lines as a guide. You are now ready to trace the enlarged image through on to the prepared watercolour paper, using a piece of transfer paper. If you are unable to buy transfer paper, you can make some by covering a sheet of flimsy paper with graphite. A thick lead pencil refill is excellent for the purpose; simply scribble on one side with the pencil until the paper is well covered. To trace, lay the transfer paper, graphite side down, on to the watercolour paper. Fit your enlargement over this and pin or Scotch tape it in position. Now trace the outline with a ball point pen, pressing just hard enough to produce a faint image. (One reason for enlarging on to cartridge (drawing) paper instead of directly on to the watercolour paper is to avoid having to make corrections and having to erase the grid lines from the prepared paper, as this can damage the surface and produce uneven washes on the finished work.) You are now ready to proceed with the finished painting.

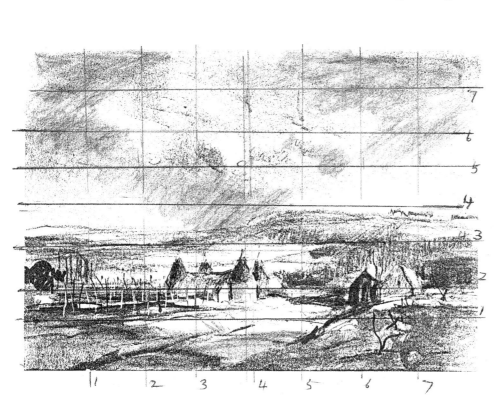

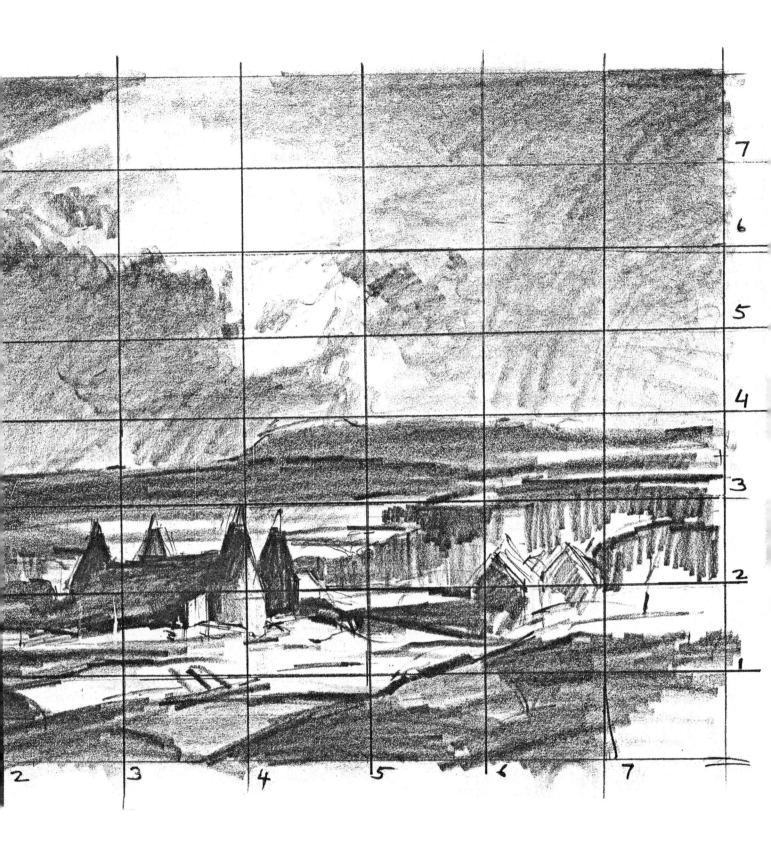

7

6

5

4

3

2

1

2 3 4 5 6 7

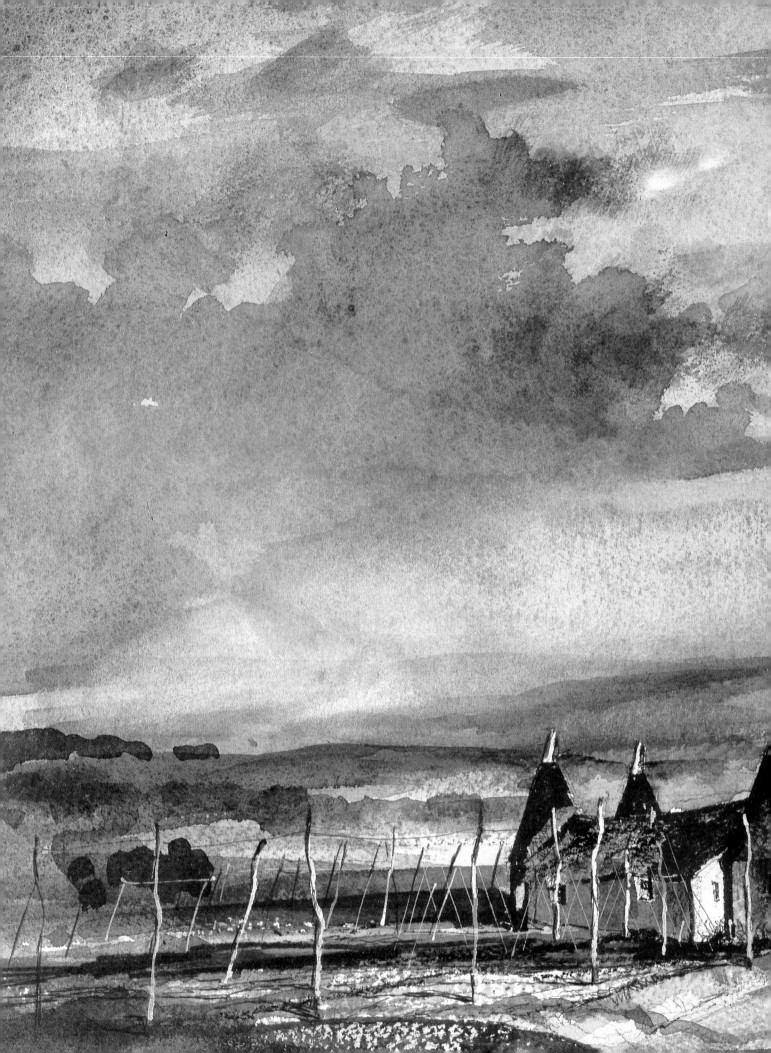

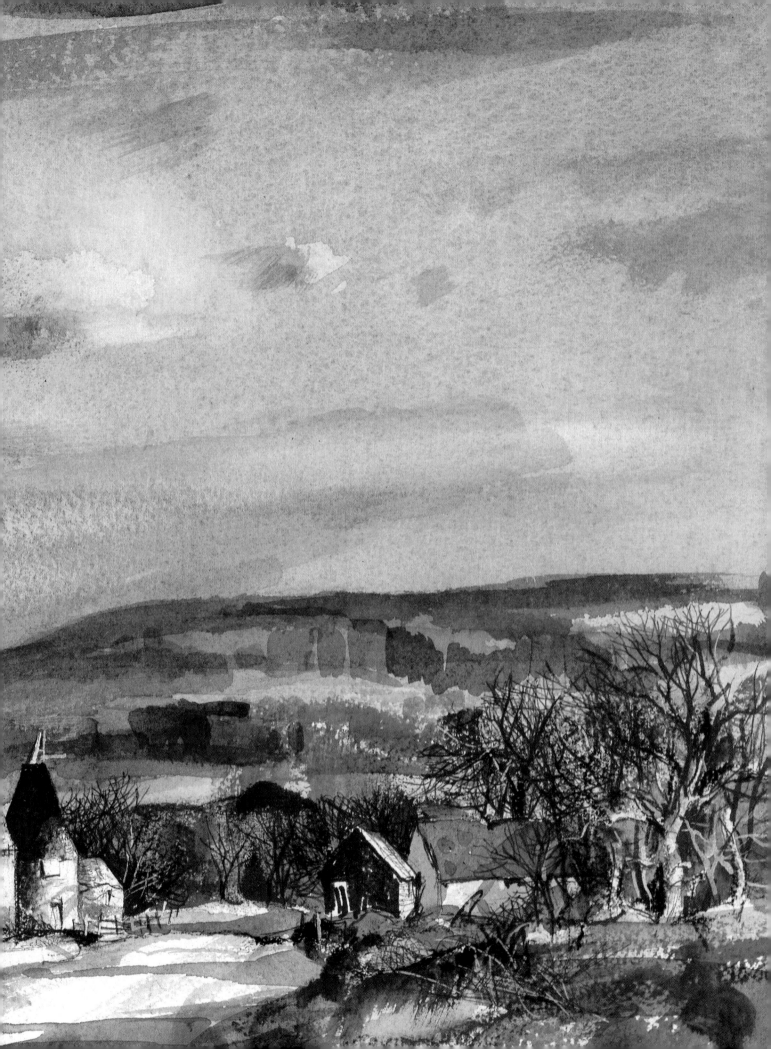

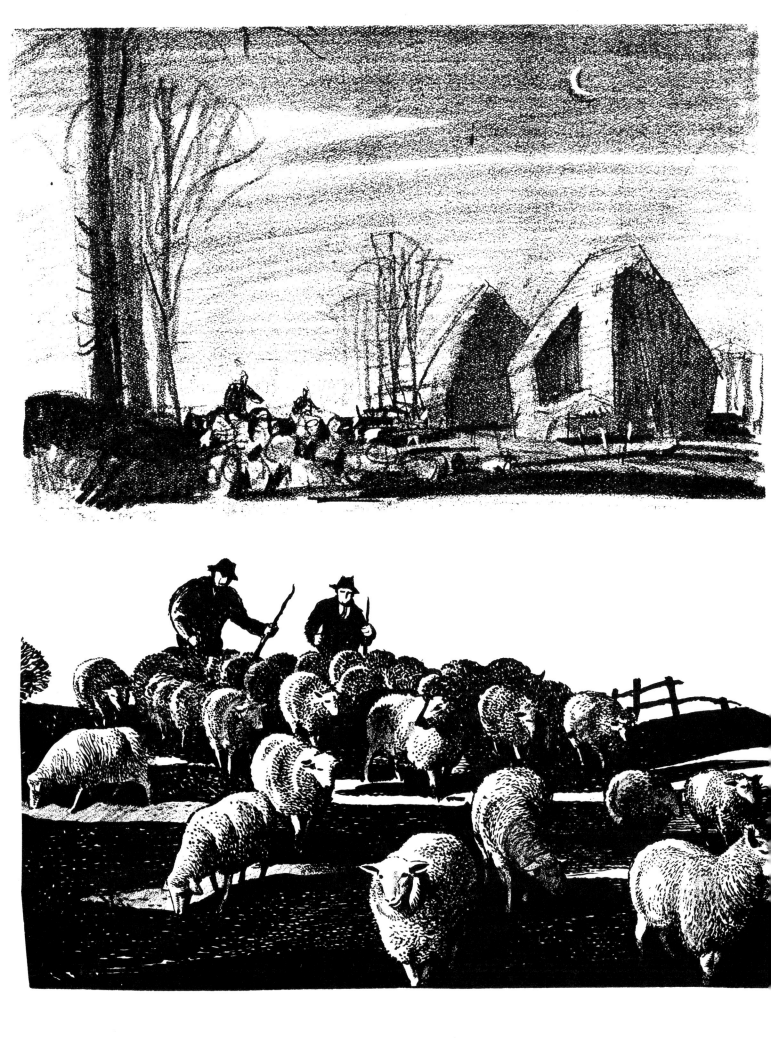

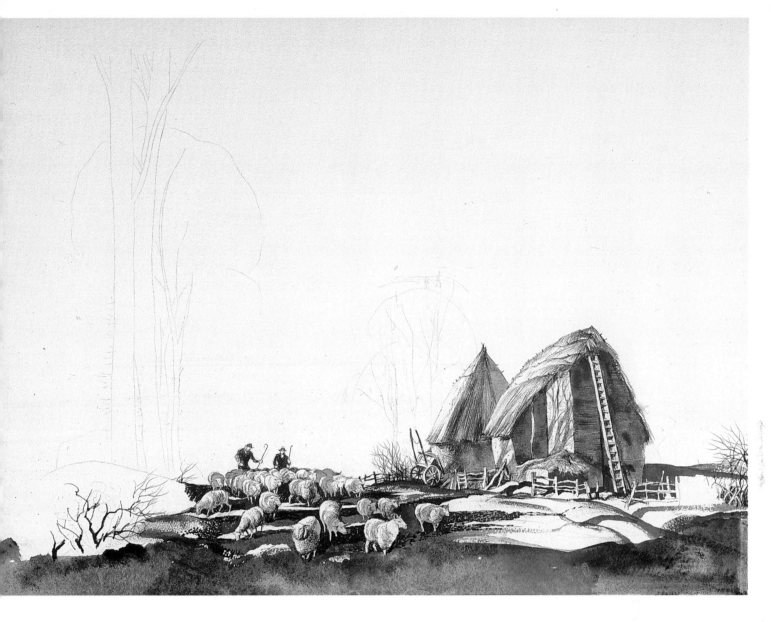

While considering suitable pictorial illustrations for this book, I was also engaged in the idea of doing an imperial-sized watercolour which aimed at evoking nostalgic memories and experiences gleaned from the past.

I had by me ready-made material which could be used as a basis for such a project in the form of studies and sketches of sheep, stacks and trees. I set about assembling this material to create a composition that would convey the feeling I had in mind. The above loose carbon pencil sketch is one of many attempts. I began by making a broad enlargement with the idea of placing the various items. I then tried to give form to the sheep and stacks using numerous past sketches and studies. I worked using brush black and brown ink, carbon pencil with sepia and grey washes to convey the idea of light and shadow. I had the idea of trying to convey the feeling of a scene depicting the effect of clear early sunlight on the foreground forms.

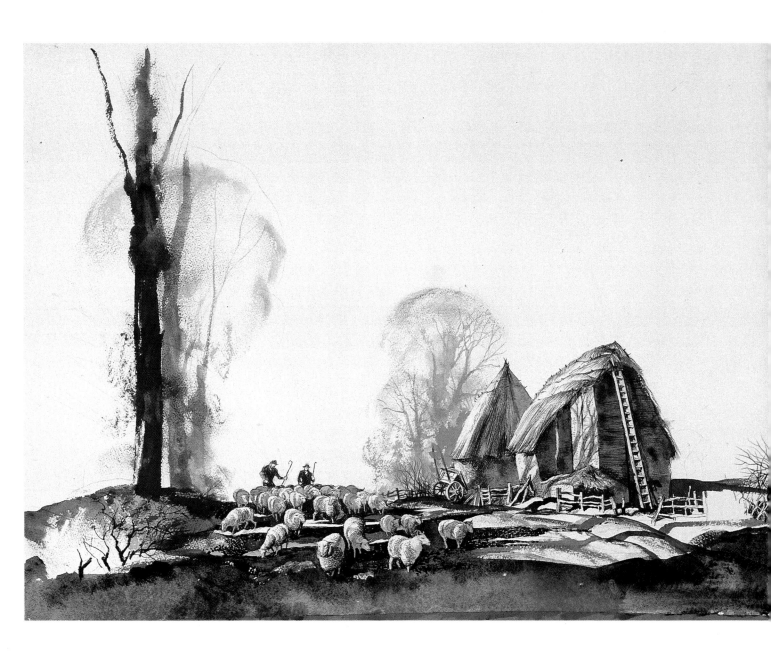

This stage shows further consolidation of the foreground objects with the addition of a loosely painted trees.

I had to face a problem at this stage; as the sheep and stacks were to be the central items of interest, I had to be careful not to dilute their importance by overworking the trees. To do so could make for a rigid static feeling. The problem then was whether two different treatments used in the same work would give rise to a feeling of disunity. I decided to see. I sketched in the trees and at once decided to leave the loosely defined shapes to convey the feeling of diffused light on an atmospheric early morning.

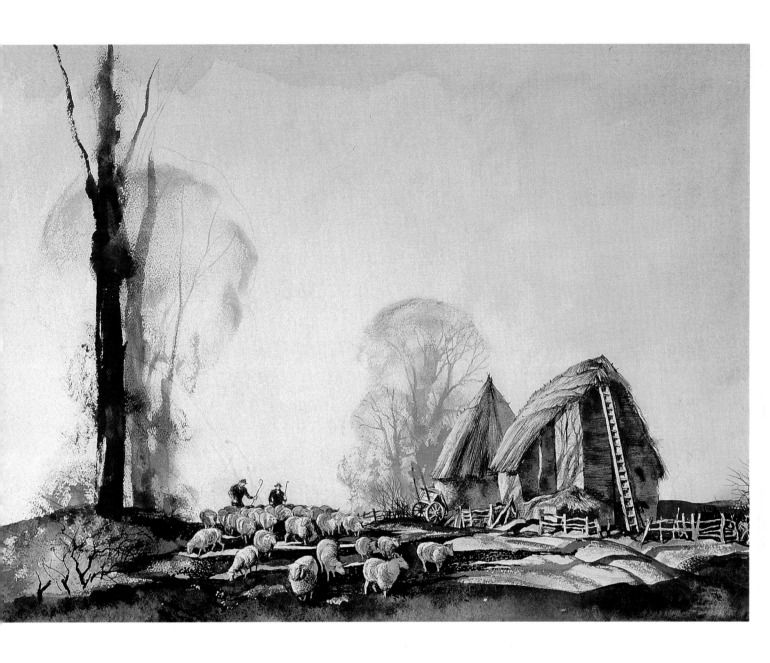

After making some additions to the foreground, a wash of raw sienna was painted over the sky graduating from a strong to a light density of colour. This aimed at conveying the impression of early sunlight.

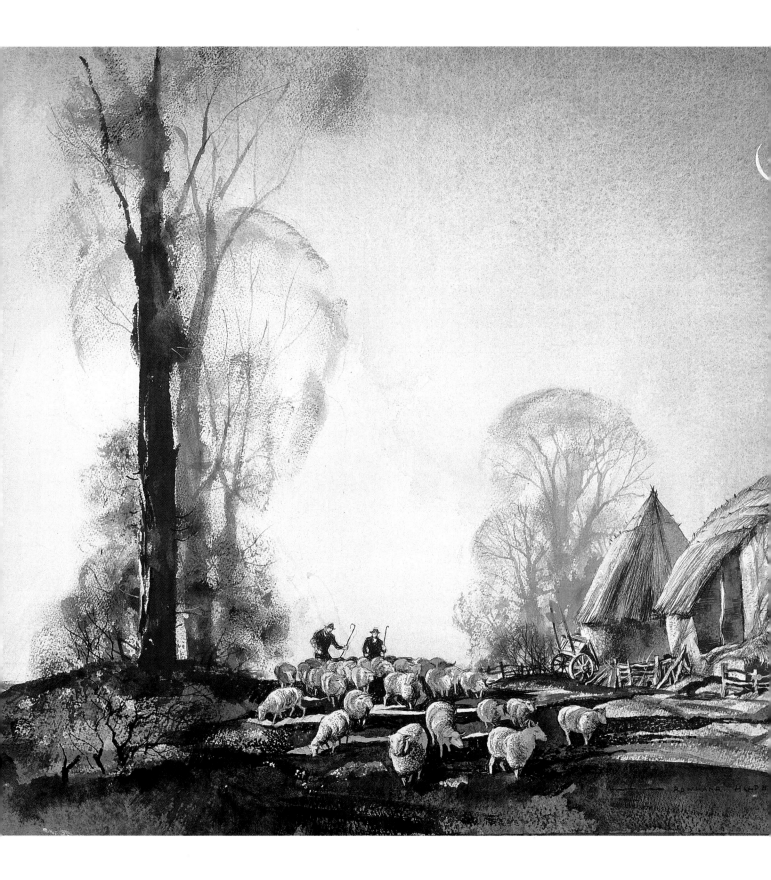

To finish – a graduated wash of blue grey was added to the sky to complete the impression of sunrise.

The new moon was painted in white body colour using an ink compass. The body colour was fed into the ink reservoir with a brush.

Before applying the compass to the sky, it was tested first on scrap paper to ascertain the correct body and thickness of colour.

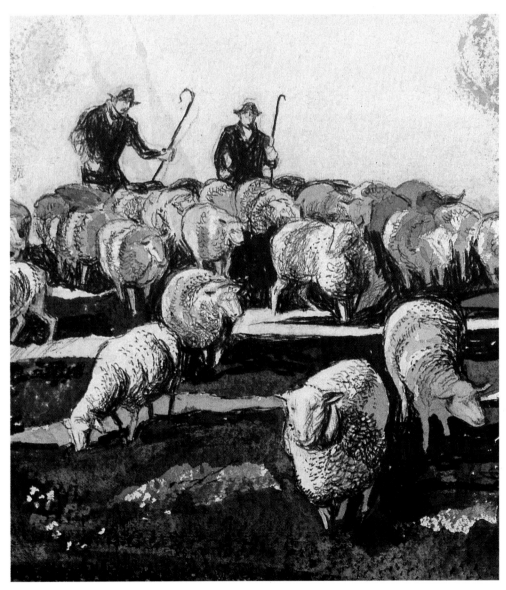

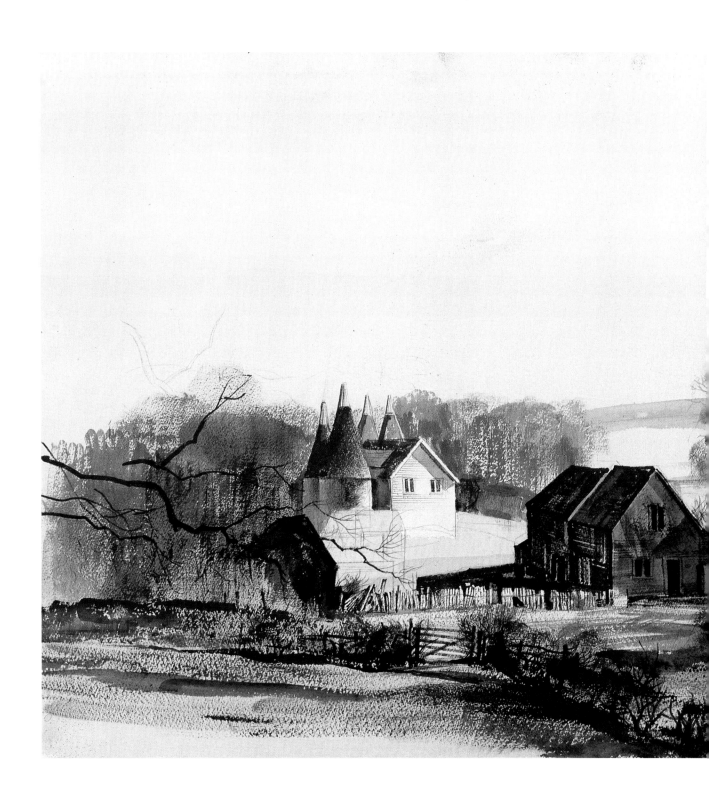

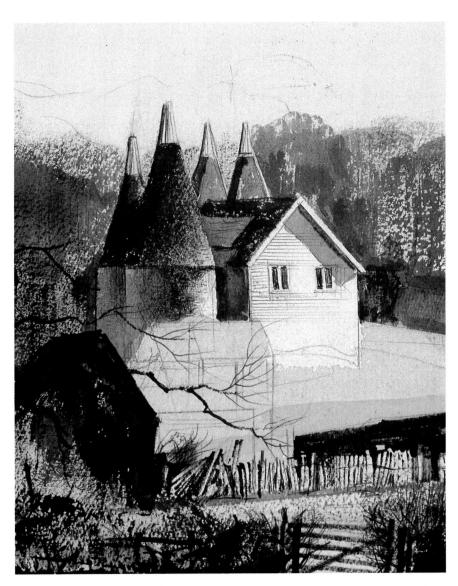

Little Bewl Bridge Farm This imperial-sized watercolour was based on numerous notes and sketches made over a period of time. The first stage was drawn using carbon pencil and black and brown ink and raw umber watercolour. The finished painting is illustrated overleaf.

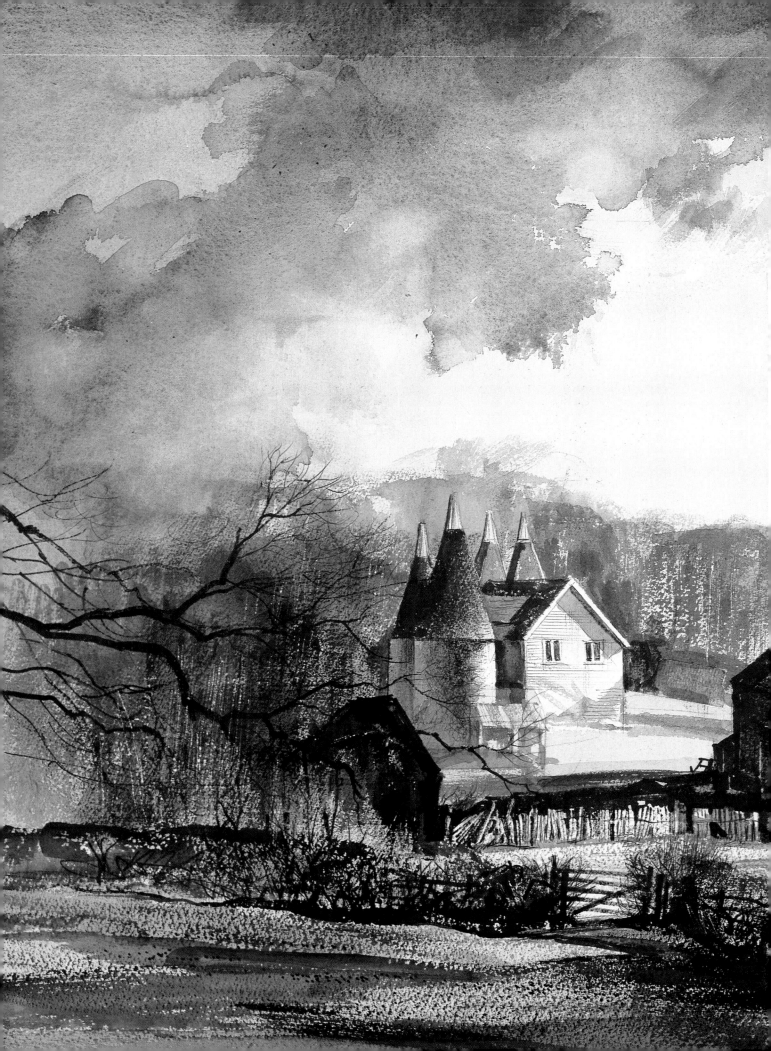

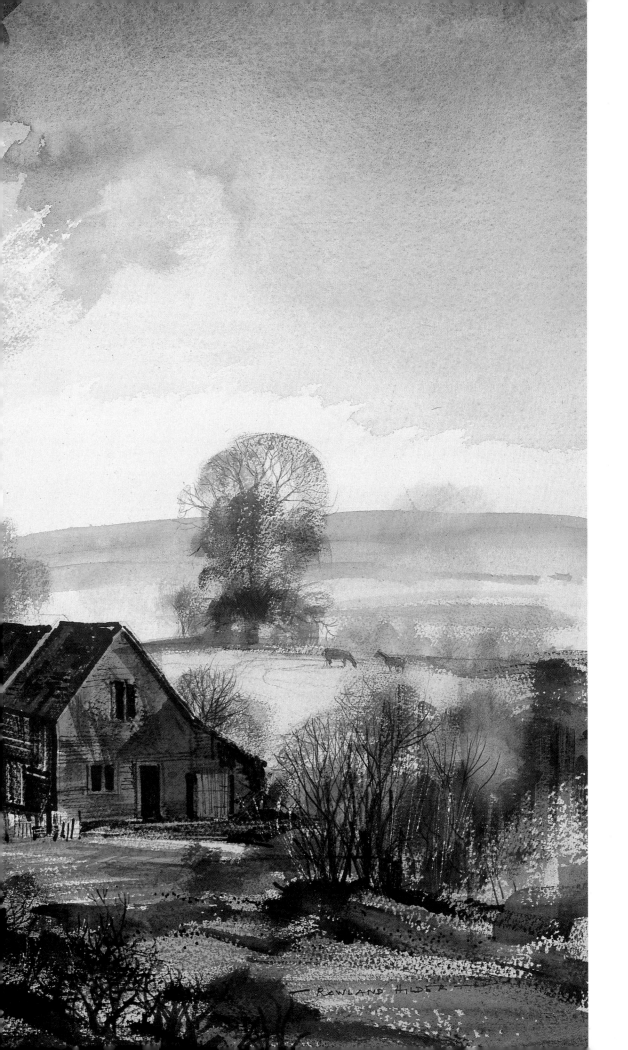

Barry Docks, South Wales This sketch depicts a complicated subject made from rough sketches from memory.

To begin with a series of trial arrangements and rough compositions were made in charcoal, working on a pad of flimsy layout paper. A fresh sheet of flimsy paper was laid over the initial sketch which consolidated the position and detail of the main basic objects. Further corrections and developments were made. The final image was then traced onto a half imperial sheet of Sanders 120lb not surfaced paper. The foreground blacks and deep tones were brushed in using a mixture of Rotring brown ink strengthened with a little black ink. After some additional line work done using a carbon pencil and ballpoint pen, and after spraying with a light fixative, the sketch was ready for further washes of grey, sepia, raw and burnt sienna. After establishing the main areas of tone, white lines of acrylic white were added for details of rigging, railings etc.

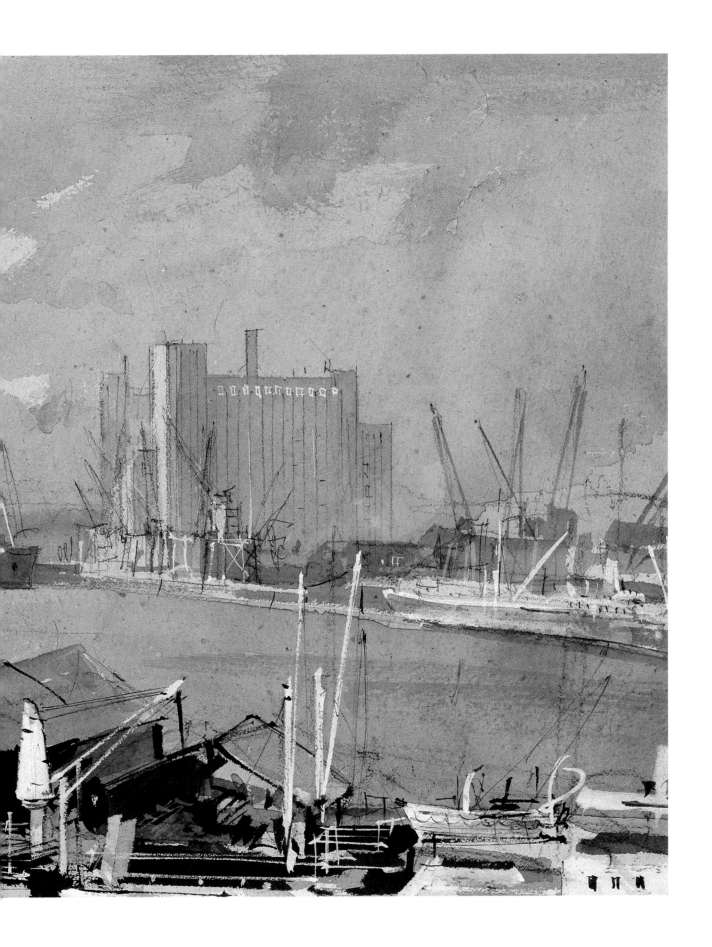

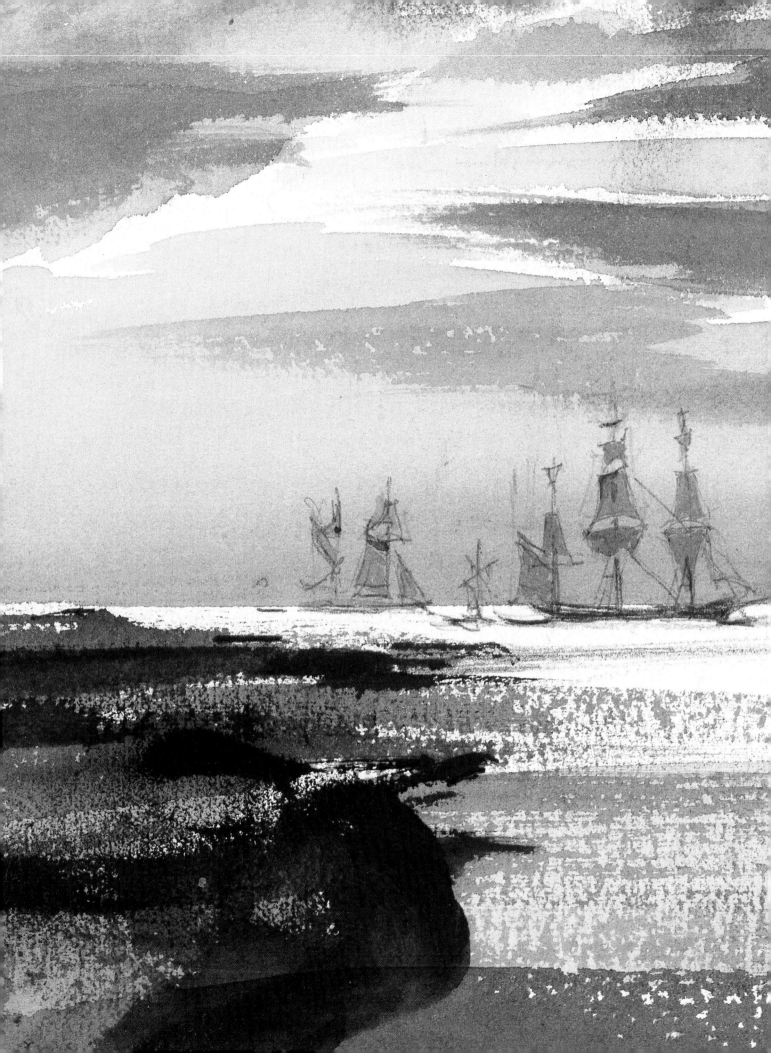

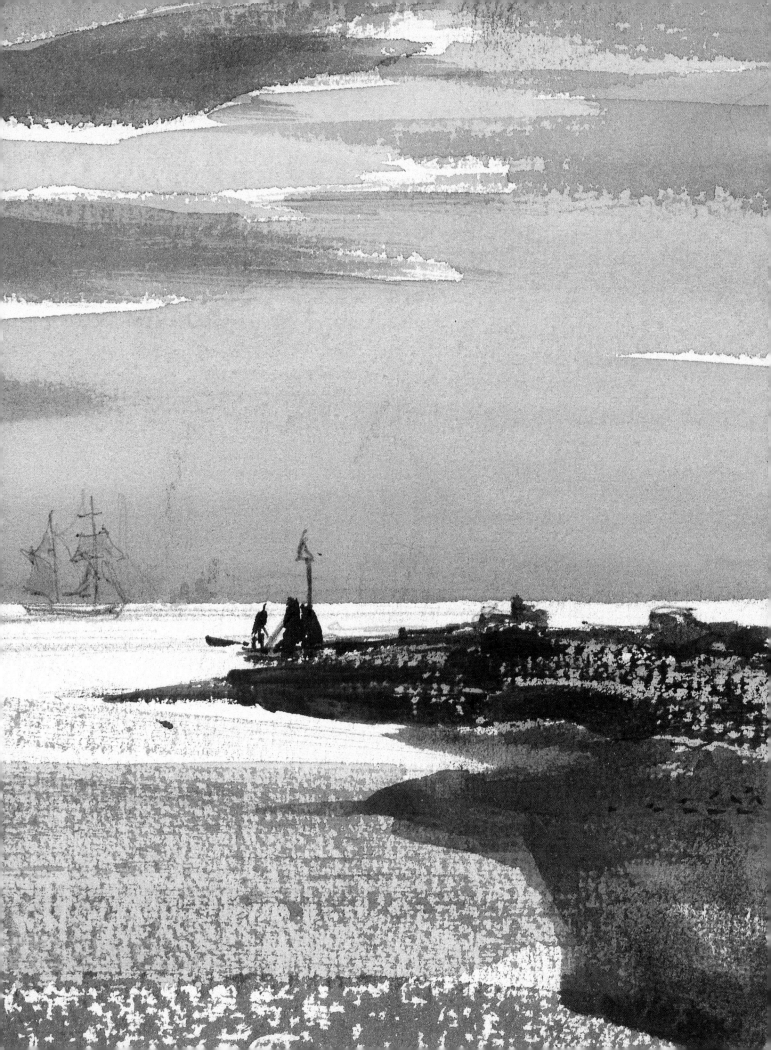

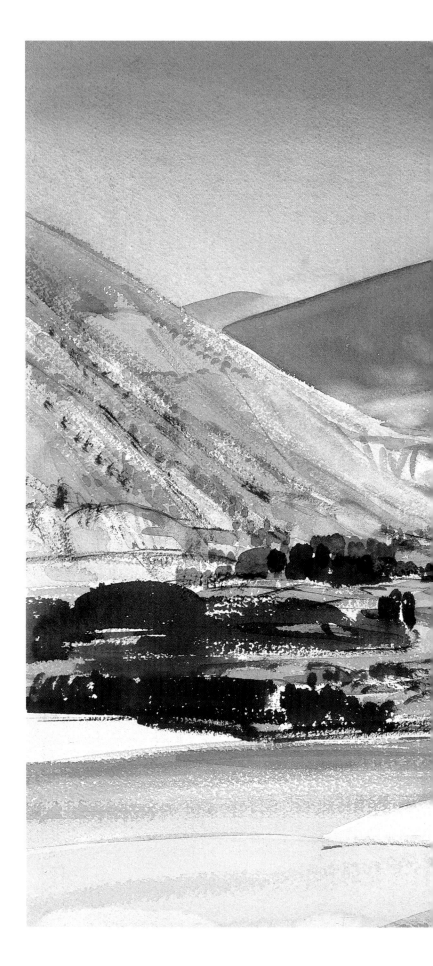

The River Aragon and The Pyrenees, Northern Spain Halting at this beautiful view I was tempted to try a large watercolour, the view and the weather being perfect. I had with me a large sheet of 300lb Green's Pasteless board. After indicating the broad outlines, I began by painting the mountains in Paynes Grey. The dark areas including trees, river and landscape were brushed in crisply. After adding a graduated blue grey sky I sponged the areas showing the misty clouds about the mountains.

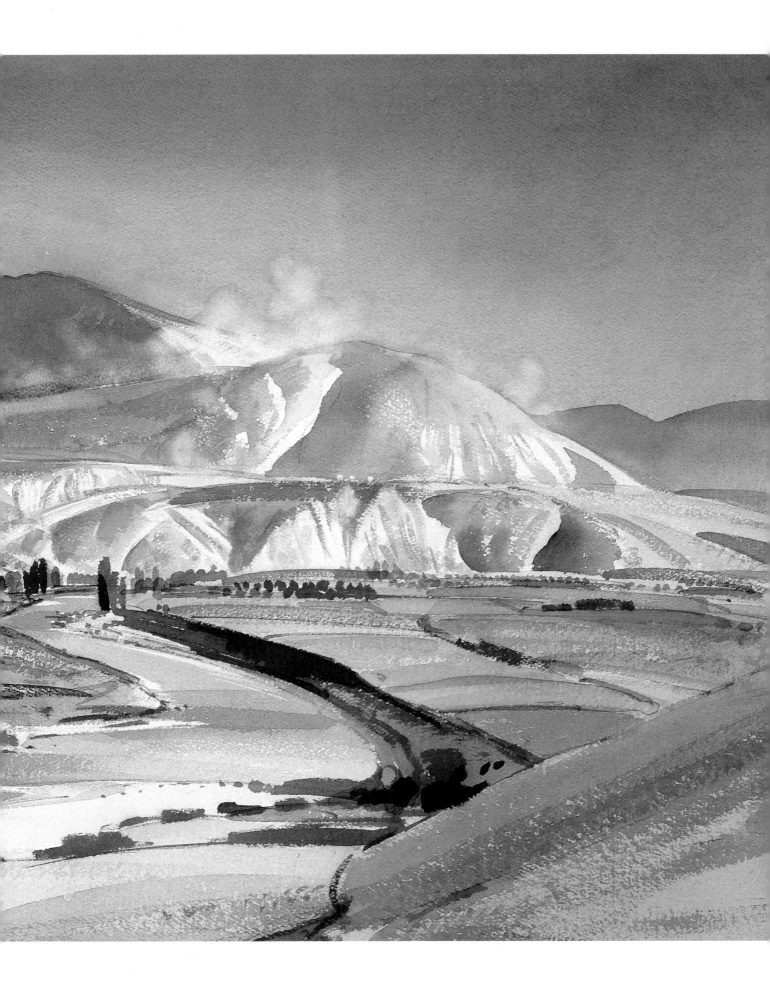

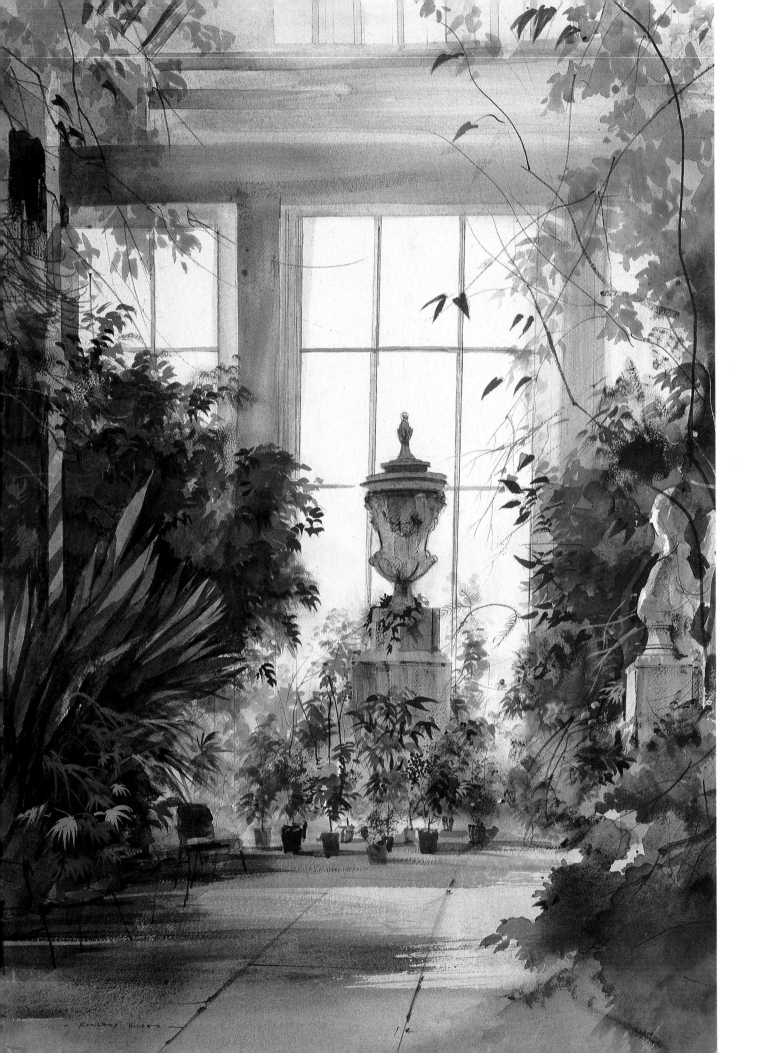

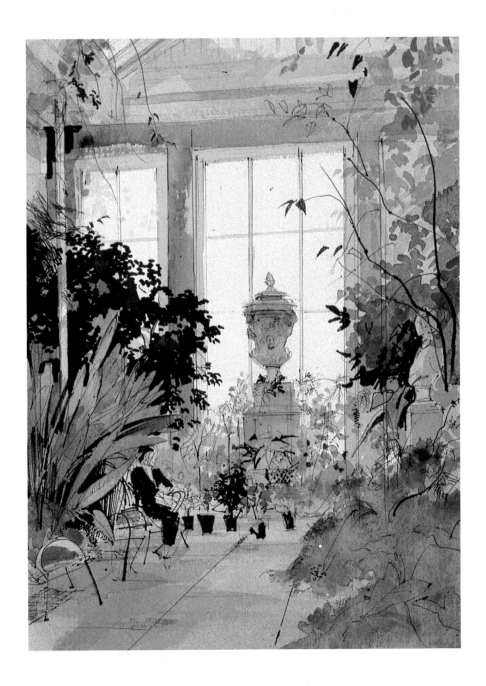

Shrublands, Essex Exhibited at the Royal Institute of Painters in Water
Colours galleries, spring 1987. The sketch above was made on location featuring
a lovely conservatory adjacent to the manor house at Shrublands. The sketch,
approximate size 14″ × 10½″, was photographed onto 35mm colour transparency,
then enlarged by being projected and traced onto a large sheet of watercolour
paper which had been mounted onto a sheet of hardboard, approximately
34″ × 24″ in size (opposite). A 'T' square was used to establish the upright
window frames, the pencil lines strengthened and confirmed with a ballpoint
pen. Parts of the urn were drawn in carbon pencil, parts being smudged to
convey the surface texture of the urn. Bits of the foliage, the figure and flagstones
were added using a felt marker and carbon pencil and fixed with an aerosol fixing
spray. Passages of deep green foliage were added using Plaka paint obtained from
most artists' colourmen.

Some hints on perspective

There is a movement in modern painting that aims at ignoring the use of perspective. Some of the results are both interesting and exciting. Certainly many paintings have been ruined by slavish rules that obscure the main function of painting, that of self expression. It is not so much that a complete knowledge of perspective is essential for the production of a work of art, as that it is more important to avoid the kind of glaring mistake that will stand out like a sore thumb, thus breaking the spell. If, however, you wish to be an architectural draughtsman, then clearly the subject will merit particular study.

For most kinds of landscape painting you don't need a full knowledge of the subject so much as a sense of what looks right in a picture. A rough working appreciation of a few basic principles may well suffice. It can, however, be maddening to try to paint a scene and fail simply because you are quite unable to convey the feeling that the foreground houses sit on the ground. The following diagrams deal with one or two basic ideas on the subject that I myself have found invaluable.

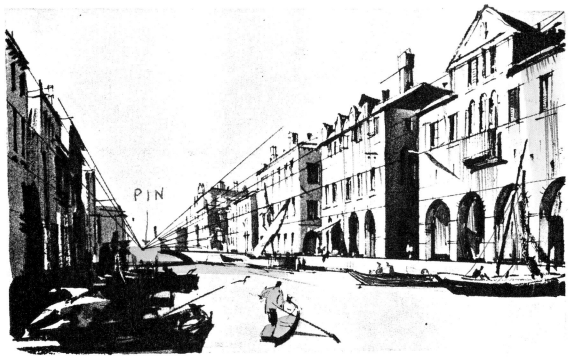

Figure 1 This drawing was made by laying a ruler against a pin. The uprights were drawn with a 'T' square.

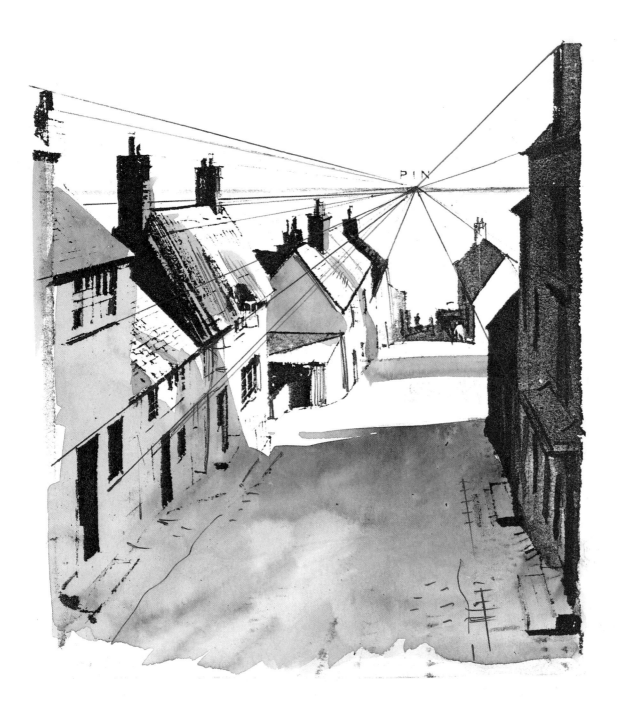

Figure 2 This is a problem that often baffles beginners. To assist in making this drawing, a pin was put through the paper into the drawing board so that it stood erect and a ruler could be laid against it, to act as a guide for the projection of the vanishing lines of houses.

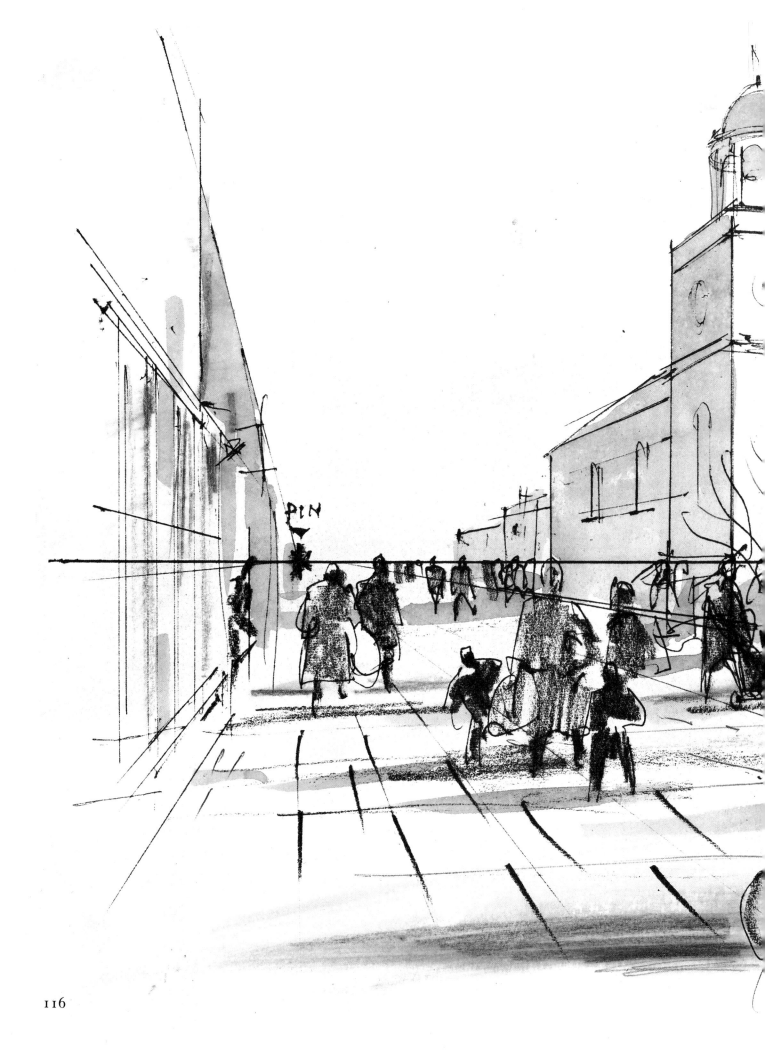

PIN

Figure 3 This sketch depicts a scene with a number of figures standing or walking on level ground. The simple rule for placing the figures in perspective is to draw all standing ones so that the horizon appears to cut them at eye level. Smaller figures will of course appear relatively lower.

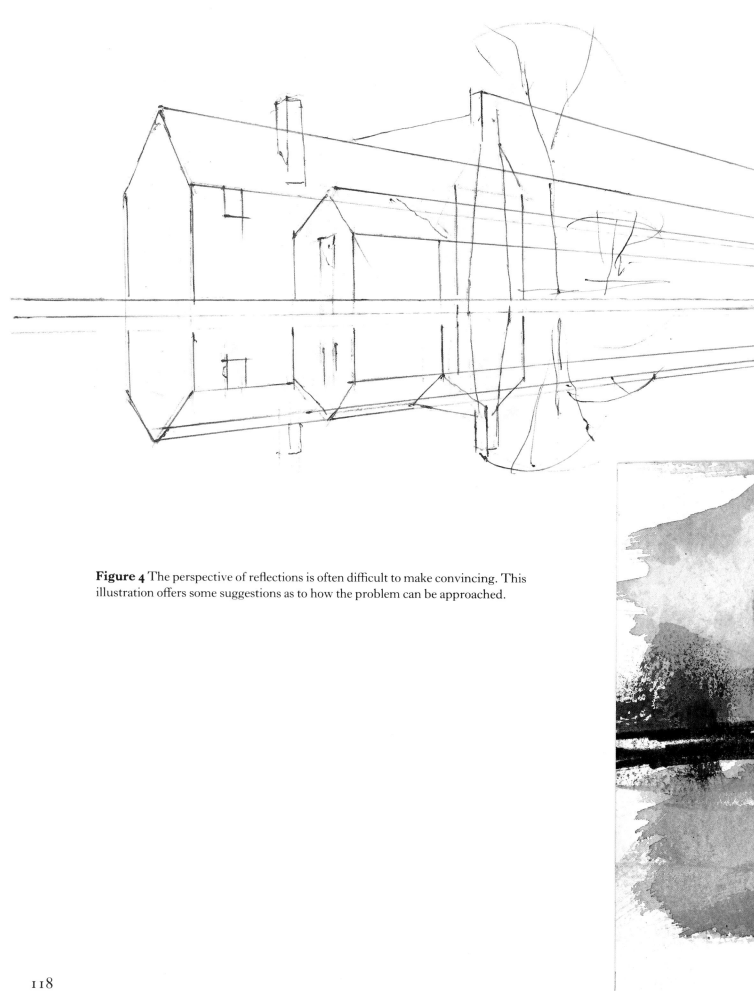

Figure 4 The perspective of reflections is often difficult to make convincing. This illustration offers some suggestions as to how the problem can be approached.

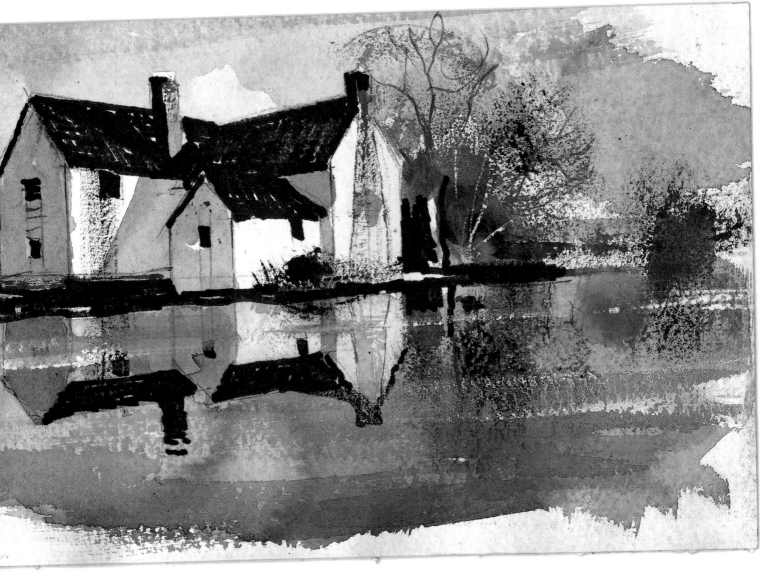

Laying a wash A large watercolour brush is essential for painting large or moderately large areas of wash. Such brushes are expensive, though it should be borne in mind that, with care, a good brush will last a lifetime. After use brushes should be washed in warm, soapy water.

It is essential to know how to apply a flat, even wash of watercolour. A fair amount of practice is generally necessary before this can be achieved.

First, mix the required colour in a saucer, making sure that it is evenly mixed. Be sure to mix enough liquid colour to cover the area you want to paint. Begin work at the top of the area to be covered, and work with the board tilted slightly towards you, so that the wash will run downwards, but not at too great an angle, or it will run down too rapidly. Apply the wash in a wide line, working from left to right. As you paint the colour will run down, forming a bead at the bottom of the brushed line. Recharge the brush and work across the paper again, easing the bead down the paper.

Too much wash will overload the bead, so that the colour will break free and run down the paper in a stream. Each wash must be allowed to dry before a subsequent wash is superimposed. This presents a difficulty in humid weather, as washes are slow in drying. Many artists carry a small portable methylated spirit heater (the kind often used by hikers) to accelerate drying. When working indoors, a wash can be dried before a fire, but care should be taken to see that the heat is not too fierce, as the paper will contract too vigorously and over-stretch to the point where it will not regain its even surface when cool.

Note on blues Prussian blue is a fluctuating colour. It fades when exposed to strong light and regains its hue when kept in the dark. Cobalt blue, while permanent, is a little greasy when used in strength and does not lend itself to the deep toned treatment typical of much contemporary work. One of the important advances of our time has been the development of the fast monastral dyes, which give us a range of beautiful blues and greens. One difficulty, however, in purchasing these colours is that manufacturers do not market them under the name 'monastral'. Thus Winsor and Newton label them as Winsor blue, Winsor green and Winsor green deep. Other manufacturers follow the same practice, giving the colours their own name – though some market the colours as phthalo. The name monastral was first used by I.C.I., and is a trade name for the group of chemicals called phthalocyanine.

Stretching paper Light-weight watercolour paper should always be stretched, otherwise it will cockle as soon as it is wetted. Heavier paper has less tendency to cockle, and many watercolour painters use very heavy paper (300 lbs) unstretched. Others favour a prepared watercolour board that is manufactured by mounting paper on to a stiff board. The latter will obviously be more expensive, and for this reason most watercolour painters prefer to prepare their own paper by stretching.

To stretch paper you must first wet it all over on both sides. (I personally immerse heavy paper in the bath for two or three hours.) When wet, the paper expands, and you must fix the edges so that when it dries and contracts, it will pull taut and flat. Many ways have been devised for securing the edges, such as patent stretching frames, but these are seldom completely successful. Many painters simply secure the wet paper by pinning the edges with numerous drawing pins (thumbtacks). I personally find that these get in the way when painting, and I strongly recommend the use of adhesive gummed tape.

Having wet the paper, now place in position on the drawing board. A piece of extra strong hardboard serves well for sizes not exceeding $22'' \times 15''$. (Use the smooth side of the hardboard.) You can ascertain the correct side of the paper by holding it to the light, making sure that the lettering is not seen in reverse.

$\frac{3}{4}''$ tape is wide enough for $11'' \times 15''$ paper, but $1\frac{1}{2}''$ tape should be used for larger sizes. Extra heavy tape is desirable for heavy $22'' \times 30''$ paper. Flatten the paper and slightly dry the edges. Cut four lengths of tape. Moisten each length shortly before application. Stick down to the edges of the paper so that approximately a third of the tape sticks to the paper and two thirds to the board. Press firmly to make sure it is secure, then proceed to stick down the two sides and finally the top and bottom edges. When sticking very heavy rough paper, special care should be taken to see that the tape is pressed well into the surface.

Allow the paper to dry slowly. Do not be tempted to dry it rapidly before a fire or in hot sunlight, as the paper may dry and contract before the tape is thoroughly dry. When working in direct sunlight, the paper may contract so much that the tape splits. To avoid this, it is advisable to reinforce the margin of the paper with a second layer of tape.

Light-fast tests

As one goes through life many things change; one's own situation, the nature of one's work, the environment, the clothes people wear, and the fashions in art. With myself, the basic addiction to sketching remains, though the drawing materials now at our disposal have changed beyond all reasonable expectation. I now have a mania for collecting and experimenting with ballpoint and marker pens.

I cannot resist buying every new one I see. I then have the fun of submitting each to a variety of tests. I test for quality of line, ease of use, for degree of waterproofness (for possible use with water-colour) and for light fastness. With the appearance of the coloured markers many of us were excited by the prospect of being able to make fully coloured line and 'wash' sketches on location without having to carry about bottles of water and mixing containers together with a container to protect one's brushes. However the prospect of being able to do an even moderately permanent work was dashed following experiments that revealed that all but a very few markers were in fact even moderately light fast. Here was a promising new medium but one which could not survive the light of day – but never-theless one which could serve to make sketches and notes for later development using acknowledged light-fast pigments.

How then did I test for light fastness? The method was quite elementary. I just drew a line across a sheet of paper with a marker or pen, noting the name and reference number for identification. Having masked half the sheet of paper to avoid exposure to light, I then placed the sheet where it could be exposed to maximum sunlight.

I viewed the results from time to time and found that the colour felt markers faded almost completely in a matter of weeks. Some of the black markers and some ballpoint pens had either almost dis-appeared or had suffered various degrees of fade. After a year all but a very few had survived. Even more astonishing was the revela-tion that about two-thirds of sepia or brown inks marketed, includ-ing some bearing names of famous colourmen, had suffered really badly. This was a shock to me as I had fondly imagined that brown and sepia inks were at least moderately 'durable' (the latter being the colourman's term for *not* all-time light-fast colour). Among the few that survived I was relieved to find that the one I had used in a stylo pen, namely Rotring, fared well.

Before testing the new markers and ballpoints I had already tested many of the standard watercolours for light fastness and had found that they behaved according to the way the makers had graded the colours, namely: permanent, durable, and fugitive. I was greatly relieved to feel that one could have such confidence in the range of basic colours available today. Nothing could be calculated to drive me 'up the wall' more than to have to grope around in semi-darkness trying to review what should have been an enlightening exhibition of important works by the masters of watercolour painting.

Staedtler
(Lumo colour)
(short)

TMS

41 KI-Koo

Bic Purple

Bic Yellow

Rushon

"Illustrator USA

Double M pen 5 - Germany

Sharpie 49

Design US

Design Art Marker US

Pentel Japan

GAMBOGE W/COLOUR

Pentel

Winsor Blue W/Col.

49

Roberson Brown

Pentouch Japan

Design 209 - L6 USA

Grey 6 USA Design

Design Brown 293 LF US

Design 209 LSF US

Design 209 - L6 Warm Grey 6 US

Design 229 - 16U US

Design 209 US

COLOUR MARKERS

Test for light fastness Having drawn lines of media to be tested, one half
of the sheet was masked leaving the other half exposed to direct sunlight.

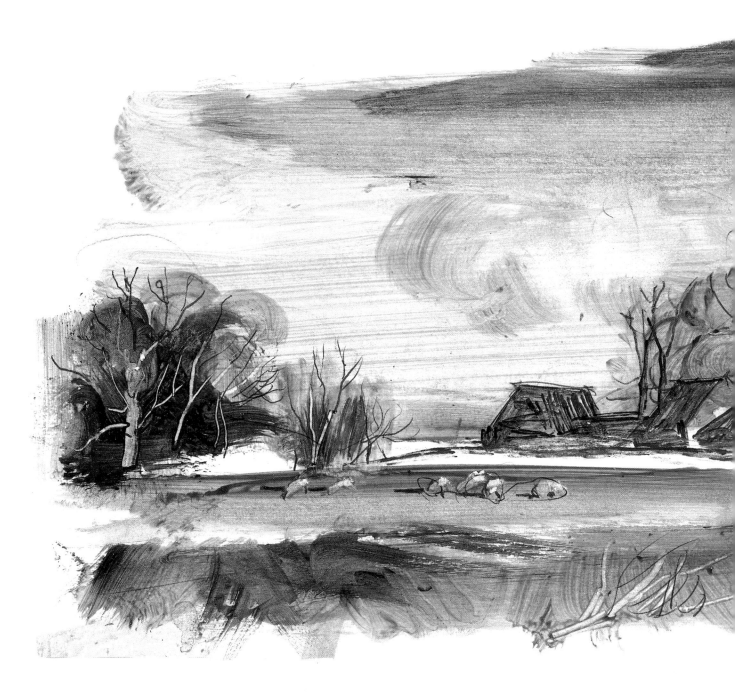

The water-colour and paste medium

Almost every painter searches for new ideas to extend his knowledge and experience of technique. Watercolour offers many possibilities for experiment. The technique used in the sketch adjacent is a revival of a style of watercolour painting developed in the last century and used by John Sell Cotman in his later works. The watercolour is simply mixed with a common adhesive flour and water paste and brushed on with a stiff brush. The ordinary hog hair brush normally used for oils will serve admirably. Once applied, the mixture can be worked about until the desired effect is obtained – or until the paste finally dries.

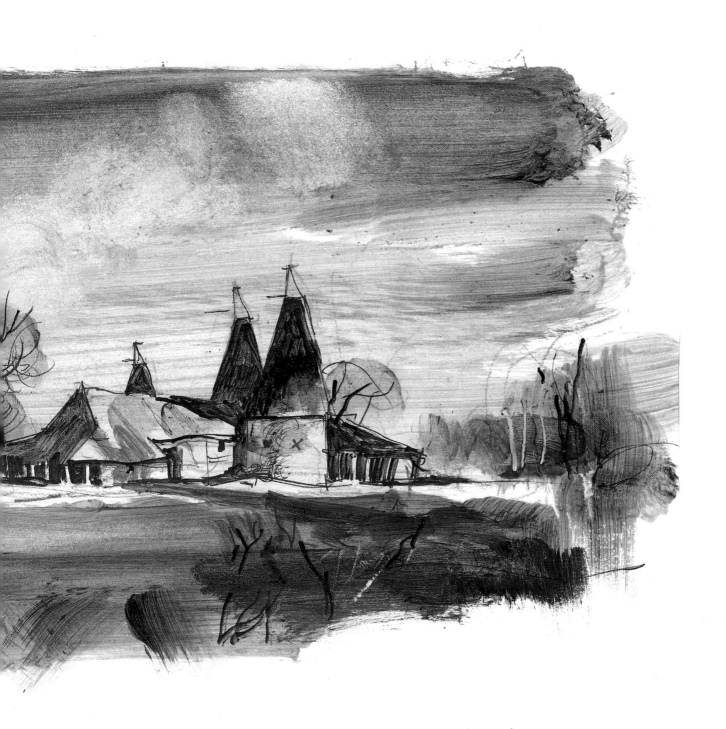

The method gives an effective transparent effect that shows the method of application, such as a wiped effect or the actual strokes of the brush. A relatively flat area of the medium can be applied by wiping with a soft rag or sponge, and by contrast, a stiff brush can be used, as in the adjacent sketch, to give the feeling of texture – the brisk direct strokes aim at simulating rough surfaces. When wet, the mixture can be removed effectively from the paper with the finger, or if a fine white line is required, the reverse end of a brush will serve. If common paste is not readily available, then one of the new wallpaper pastes will work equally well.

Conclusion

Having lampooned the pundits in the introduction of this book for making rules, it may strike you as odd that I should end by making rules myself.

I have (as I explained) been more hampered by rules than helped. However, on reflection, I feel that there are some guiding principles that have been valuable to me in moments of difficulty and confusion. I have set these ideas down for what they are worth, while at the same time entreating that they should not be read as gospel.

Having recently looked at a number of watercolours by beginners, I was struck by the fact that most of the painters overfilled their pictures, packing almost the whole picture area with confused, fussy detail. The first rule, then, that I put forward for your consideration is that you should keep a fair sized, flat, open area in your picture as a restful space. It will set off and add significance to the other parts of the picture.

Aim to paint in simple, flat areas of wash, using correct tone rather than fussy, niggling detail to convey a feeling of conviction.

Try to capture a mood rather than become involved in slavish copying of what is before you. Remember that one should aim to work a spell on the viewer, to stir his feelings. Do this in the simplest and most direct way possible. Don't bore the viewer with a display of mundane copying of dreary subject matter. Find out by a process of self-questioning what you really like and what moves you most. (This is not as easy as it sounds.) Then go all out for these things and do not be deterred by the casual art club critic.

Once again, keep your washes clean, simple and flat. This will help you to strive towards the development of a sense of the pattern and relationship of shapes. Try to see the elements of your picture as a series of shapes and contrasting tones that will convey the essence of your message in clear, easily read and understood terms.

Aim to gain enough confidence to be able to paint directly, and then leave your picture alone. Remember that the watercolour medium can be very beautiful in itself, and that even an ugly slum can be made the subject of a beautiful picture.

Finally, do not let painting become a dreary chore. It can and should be the most absorbing, exciting and rewarding activity yet devised.

Index

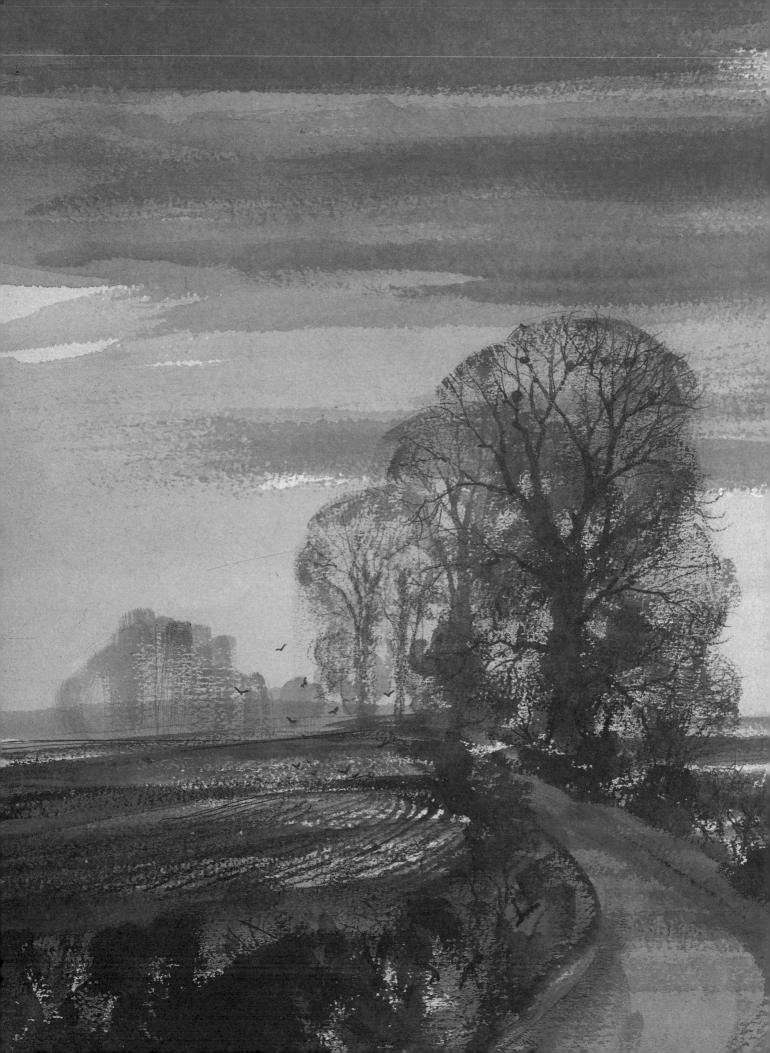